Collins *gem*

Sketching

D1581779

Techniques & tips for
successful sketching

Jackie Simmonds

First published in 2006 by
Collins, an imprint of
HarperCollins*Publishers*
77–85 Fulham Palace Road
Hammersmith, London W6 8JB

The Collins website address is: www.collins.co.uk

Collins Gem® is a registered trademark of
HarperCollins Publishers Limited.

12 11 13
6 5
© Jackie Simmonds, 2006

Jackie Simmonds asserts the moral right to be identified as the
author of this work.

A catalogue record for this book is available from the British Library

Created by: SP Creative Design
Editor: Heather Thomas
Designer: Rolando Ugolini

ISBN-13 978 0 00 720327 7

Colour reproduction by Digital Imaging
Printed in China

CONTENTS

ABOUT THE AUTHOR

Jackie Simmonds attended art school in the 1970s and has worked ever since as a full-time artist and art instruction author. She exhibits regularly in the UK, and reproductions of her work have been distributed world-wide. She writes articles for *The Artist* magazine, runs workshops and painting holidays, and has written six art instruction books as well as making six instructional videos.

Photo: Patricia Ravnar

She has won two major awards for her work, and was recently elected to full signature member of the Pastel Society of America. In 2005, she was featured by *The Pastel Journal* in the USA. Although pastels is her favourite medium for full-scale paintings, she uses all media for her sketches. She travels widely for her subject matter, producing finished works on location and in the studio. Jackie's work can be seen on her website, www.jackiesimmonds.com, and she can also be reached by email through the website.

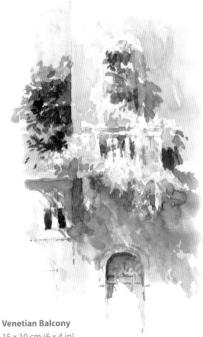

Venetian Balcony
15 x 10 cm (6 x 4 in)
This image was used later for a full-scale painting of the subject,
in pastels, because there was plenty of information to use.

INTRODUCTION

So often I hear people say 'I wish I could draw, but I can't even draw a straight line'. Well, actually, neither can I but even someone who cannot draw a straight line can learn to draw. All you require is a few basic essentials, in terms of materials, and lots of enthusiasm. You need patience, too, because you have to learn how to see before you start to draw, and your skills will develop slowly. However, with enthusiasm and determination, you *will* learn, and you *will* improve.

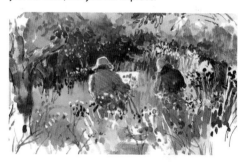

Sketching in the Olive Grove
17 x 25 cm (7 x 10 in)
This sketch in watercolour and gouache was done in Greece. Leaving areas of white paper gives a lively feel.

You will find some fairly accomplished drawings within the pages of this book, but please remember that I have been sketching and drawing for many years. I was equally inexperienced when I began, but I persevered and now can draw reasonably well. The good news is that you, too, will reach a level of competence in the fullness of time. The important thing is to enjoy the practice, and you will find that your sketchbooks and drawings will become items to treasure over the years.

DRAWING VERSUS SKETCHING

Sketching is a kind of visual shorthand – the best sketches are done quickly, and there is little emphasis on 'finish'. A sketch can be loose and spontaneous. Drawing, however, is a slower and more deliberate process. The artist takes time to develop a more elaborate, detailed, intensely observed image.

You will find both sketches and drawings in the pages of this book. I recommend that you aim to fill your sketchbooks with both sketches and drawings. In this way, you will develop both your observational and your technical skills to the full, which will feed your confidence – and your sense of enjoyment. Above all, don't worry! No-one need see your sketchbooks until you are ready to show them. This is a wonderful journey, and you will have lots of fun along the way.

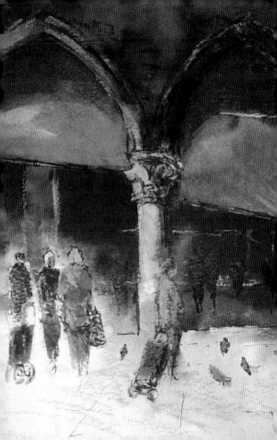

PART ONE

Getting started

One of the great things about sketching and drawing is you do not need masses of kit. You can use just about anything which makes a mark! I will show you how to work with pencils, pens, pastels and watercolours as well as brush pens, fibre tips, watersoluble pens and pencils. Try everything and, as you master your materials, you will quickly discover what you like best, and what best suits the subjects you choose. Gradually, you will feel the joy of creation and will achieve, on the two-dimensional pages of your sketchbook, drawings and sketches that represent our three-dimensional world.

Sunlit Awnings
25 x 17 cm (13 x 7 in)
This image was sketched on the spot in Venice, using a tiny pocket watercolour box. When sketching outdoors, sit with your back to a wall to prevent people looking over your shoulder.

MATERIALS

Our art materials shops are awash with drawing and sketching 'implements' but, to save confusion, I have selected only a few for you to try. There is no point in purchasing masses of equipment when you can produce excellent drawings and sketches with just the materials that are used in this book.

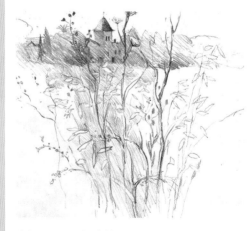

Château Across the Field
15 x 15 cm (6 x 6 in) 3B pencil in sketchbook

PENCILS

The most obvious sketching tool is a pencil. Graphite pencils are graded – 9H is the hardest whereas 9B is the softest. I suggest that you try an HB, a 2B and a 4B. The softer pencils will give you greater sensitivity of line and richer darks. Some graphite pencils are now watersoluble, allowing for interesting soft effects when the marks are melted with water.

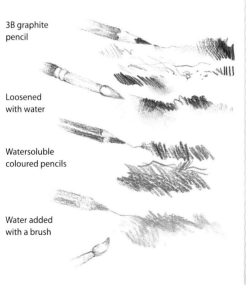

3B graphite
pencil

Loosened
with water

Watersoluble
coloured pencils

Water added
with a brush

CHARCOAL STICKS AND PENCILS

Charcoal works best on paper with body and slight texture, rather than a very smooth paper. It responds to the lightest pressure and smudges well, but while it can be corrected easily and is ideal for quick sketches

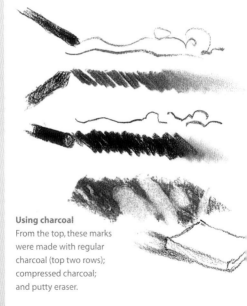

Using charcoal
From the top, these marks were made with regular charcoal (top two rows); compressed charcoal; and putty eraser.

it is less good for detail. You can buy charcoal in thin, medium and thick sticks. It is best sharpened on a sandpaper block. A charcoal pencil is cleaner to use and is useful for linear work but, unlike a stick, cannot be used on its side for greater coverage of the paper. Compressed charcoal is a dense form of charcoal stick, which will give a much blacker mark.

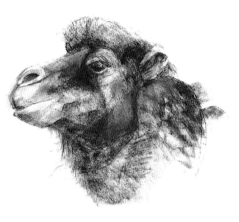

Camel's Head
50 x 40 cm (20 x 16 in)
This student's drawing was made with vine charcoal and some condensed charcoal.

CONTÉ CRAYONS

Conté crayons can be purchased as sticks or pencils. They behave much like condensed charcoal, but the marks are more difficult to erase than charcoal. Conté crayons can be black, white, red (sanguine) or dark brown (bistre), and can be used together on coloured paper for very effective drawings and sketches.

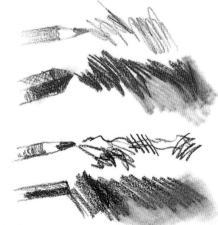

Conté crayons

These marks were made with conté crayons. From the top: sanguine (two rows), and bistre (two rows).

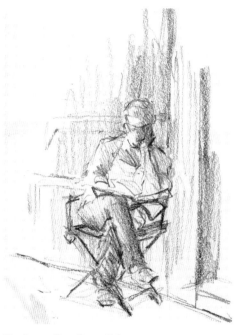

The Grocery Store Owner, Italy
15 x 10 cm (6 x 3 in)
This man sitting reading was captured in a quick sketch on
cartridge paper in a sketchbook, using bistre conté pencil.

PASTELS AND PASTEL PENCILS

Pastels can now be purchased either as sticks – hard or soft – or in pencil form. Which you decide to use is a personal choice, but when I use them for sketches, I tend to favour hard pastels – I keep my soft ones for more fully-realized paintings.

Pastel pencil marks

Pastel stick marks

Hard pastel sticks and pencils are great for sketching; you can achieve colourful drawings quickly and easily. A stick has the advantage of great coverage when used on its side. However, all pastel drawings and sketches will need to be fixed or they will smudge.

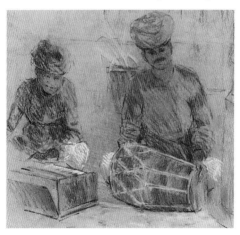

Musicians, India
30 x 30 cm (12 x 12 in)
This loose, lively sketch was made quickly on the spot with pastel pencils on pink coloured paper. It has enough information to make the scene come alive in my memory.

WATERSOLUBLE MEDIA

Brush pens

In recent years, these have made an appearance in art shops. I favour the ones with a hard tip at one end, and a wider 'brush tip' at the other. This gives great variety of marks, and, to add to the fun, the marks can be dissolved with water.

Watersoluble crayons

These are also lovely to use – on a slightly rough paper, the marks will break up nicely and give an impression of texture. When dissolved with water, the marks melt into delicious washes of subtle colour.

Brush pen using pen tip

Brush pen using wider 'brush' tip

Watersoluble crayon

Guadelest, Spain
15 x 10 cm (6 x 3 in)
Watersoluble brush pens were used for the main elements
of the image, and the marks partially dissolved with water.
To increase the texture of the rockface, pink watersoluble
crayon was stroked over the top and left undissolved.

DRAWING PENS, DIP PENS AND INKS

You can use any kind of pen for sketching, including fountain pens and ball points. My favourite sketching pens are the kind with a dipping nib, used with either inks or concentrated watercolours which are sold in bottles, or fine fibre-tipped artist's pens. I particularly enjoy a fine-tipped waterproof artist's pen which is

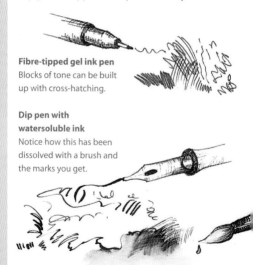

Fibre-tipped gel ink pen
Blocks of tone can be built up with cross-hatching.

Dip pen with watersoluble ink
Notice how this has been dissolved with a brush and the marks you get.

filled with brown Indian ink. Although the line can be rather monotonous, the ink is a lovely colour – softer than black – and no bottles of ink are required. However, I sometimes use a sharpened stick which has been dipped in ink – it can give blobby results, but these can provide an interesting look. It is best that you try a variety of pens in order to discover which you like the best.

Cyprus Sketch
10 x 15 cm (4 x 6 in)
This was created with a dip pen and dark green concentrated watercolour. The fine linear strokes were built up gradually for dark areas. Swift, long strokes were used for foreground grasses.

WATERCOLOUR AND GOUACHE

The essential difference between watercolour and gouache is that watercolour is transparent whereas gouache is opaque. For sketching, both mediums work well, either together, with pencil or pen linear work, or on their own. You can use a sketchbook, but choose one made with fairly thick cartridge paper or watercolour paper. The paper will not buckle too much if you do not splash around with lots of water. Watercolour boxes, with half-pans, are great for sketching, particularly those that have integral wells and a water bottle. Gouache comes in tubes, and you will need a palette for mixing colours.

Watercolour is transparent
If used over a pencil sketch, you can see the original drawing.

Gouache is opaque
The marks will cover the original drawing.

Pocket travelling watercolour box
This includes a waterbottle, small brush, waterpot and mixing wells. I use mine regularly together with a bigger, retractable travelling paintbrush.

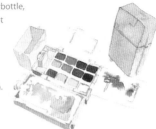

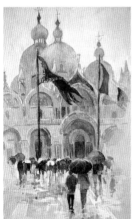

St Mark's Square, Rain
27 x 20 cm (11 x 8 in)
This sketch was made on 90 lb watercolour paper on the spot, in the shelter of an archway. I used a tiny pocket watercolour set, plus a tube of white gouache to mix with and make the watercolours opaque in places.

SKETCHBOOKS

These come in all sorts of different shapes, sizes and colours. It is a good idea to carry a small pocket sketchbook all the time to use wherever you are – in the library, at the station or an airport – this is great practice. Buy larger sketchbooks for use at home, and when you travel. Try ones with watercolour sheets as well as strong cartridge sheets. Coloured sketchbooks are fun to use for a change of pace and a totally different look to your drawings and sketches.

Papers

These come in different grades, from inexpensive sugar paper to the most expensive handmade ones. You can also buy different weights, from flimsy through to rigid board. For general use, 185 gsm/90 lb works well. Expensive, heavy papers look and feel wonderful but they can inhibit your approach due to their cost, and you can produce excellent drawings on more economical papers. Whatever paper you use, try to ensure that it is acid-free, or it may discolour over time.

I tend to avoid shiny surfaces, and prefer those with a little texture (tooth), since this adds character to the quality of the line. A Hot-Pressed surface is also good for drawing – although it is smooth, it is quite mat.

Sketchbooks

You will probably need several sketchbooks with different papers and in a range of sizes. Spiral-bound ones are useful as they open out flat for when you are working outside.

OUTDOOR KIT

Sketching out of doors can be a little daunting at first. You have to deal with less comfortable conditions; changing light effects and weather and the problems of transporting your kit. You might also have to cope with onlookers, insects, stray dogs, thirst, excessive heat or cold and inconvenient calls of nature! Begin gently, perhaps by working in your garden or in a park.

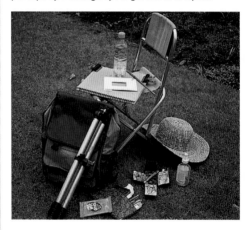

Outdoor sketching kit
A selection of art materials and kit for working outdoors.

What you need

Everyone develops their own favourite outdoor kit, but here are some helpful guidelines to what you need:

- Knapsack or a bag with wheels – depending on your strength!
- Sketching stool with backrest.
- Lightweight sketching easel (optional).
- Sketchbook with bulldog clips to prevent pages from blowing in the wind, or a drawing board with paper attached by bulldog clips.
- Pencil case, containing your preferred sketching tools – pens, pencils, charcoal, etc.
- For painting – a small pocket paintbox plus a travelling brush.
- Bottle of water – for drinking and brush washing.
- Tissues.
- Wipes.
- Small can of fixative (not essential).
- Long-handled brush, or bamboo stick, for measuring.
- Viewfinder.

Note: I recommend that you keep your kit weight to a minimum. A good monochrome sketch from life will tell as strong a story as a full colour sketch, but a sore back from carrying a lot of heavy gear will prevent you from working at all!

TECHNIQUES

When we draw an object, we make two-dimensional marks on a two-dimensional surface to represent a three-dimensional object. So nothing is real. We are simply doing our best to communicate, with marks, how we see our subject, both objectively and expressively.

When we draw a line, we are making a mark. When we smudge a charcoal line, that is a mark, too. In isolation, marks are meaningless – but used appropriately, related to the subject matter before us, our marks will help us to *describe* the form and structure of our subject. This is quite a different matter and should be the main aim of every artist.

You should practise in order to extend your arsenal of marks and also to become conscious of the possibilities available to you. I will give

you some suggestions, but within this small format, these are purely starting points. Remember that although you can be creative with your tools, you can push even further – smears, blots, scratches and erasings are all marks, too.

A sheet of techniques marks

Making these feels playful but will teach you a great deal about the kinds of marks you can make with your available materials.

THE RESPONSIVE LINE

When we pick up a pencil, our first impulse is to make lines. Initially, we use line to define the outer edges of an object or a scene; but then we need to learn how to use internal lines to describe the form of the object and also to give it a sense of three dimensions.

Different media
A variety of lines that you can make with different implements.

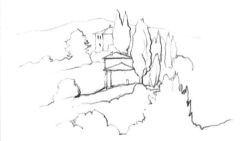

Tuscan landscape
A 3B pencil is used for a linear sketch of a Tuscan scene. The varying weight of line has an organic feeling. Varying the pressure on a pencil will give different weights of line.

Using line

Different drawing implements will provide different types of line. Practice will allow you to begin to use line in order to express your feelings about your subject. A pencil can give a delicate, sensitive line if used lightly, and by pressing harder, or using a softer pencil which provides a darker line, you can achieve firmer, more positive linear strokes. A rolling ball pen will give a monotonous line, whereas a dip pen will provide wonderful variety.

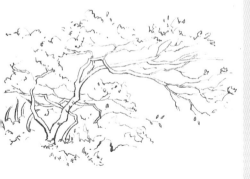

Bush sketch

A dip pen, with sepia coloured ink, was used for this sketch. The nib of a dip pen allows both light and heavy linear strokes.

TONE SUPPORTS LINE

Although one can achieve a strong sense of three-dimensional form with the use of line alone, the addition of 'tone' will add dramatically to the illusion of three dimensions and can also provide an element of atmosphere in your work.

Tone is commonly known as 'shading' when using dry media. Areas of tone can be built up in a variety of ways: 'cross-hatching' is one approach – building up lines in varying directions over each other until a continuous tone is achieved. The side of a pencil lead or piece of charcoal will also provide tone. Create areas of tone by softening linear strokes with a torchon (rolled tube of paper).

Apple outline

This shows a linear outline. We can see the form because of the internal lines used for the dip in the fruit.

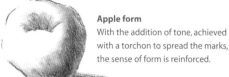

Apple form

With the addition of tone, achieved with a torchon to spread the marks, the sense of form is reinforced.

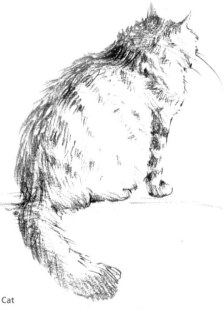

Cat

In this conté pencil drawing of a tabby cat, both line and tone are at work. We can see the three-dimensional form of the cat because of marks and shading which suggest fur as well as the form. White paper is left to show light hitting the cat from the right.

TONE WITHOUT LINE

As children, when we wanted to draw a house, we would draw a box with a triangle on top for the roof: the outline edges of the house in our imagination. As adults, however, we need to let go of the idea of everything having an 'outline'. Where is the 'outline' of an apple or a person? A box may have edges but there are no 'edges' to an apple or a person. We have learned how tone supports line. Now let's see how line can, in fact, work against, rather than with, tone.

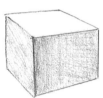

Box with line
This box was sketched with line for the edges, and tone to show how the light is hitting it. It works quite well, but do we need both the line *and* the tone?

Box without line
Here the line is lost into the tone, yet the box's three-dimensional form is still apparent. We need the line to show the top of the box, but not at the sides where the tone does the job.

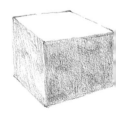

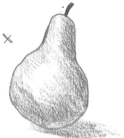

Pear with outline
Sometimes line and tone used together can work against what you wish to achieve. The line drawn firmly around the pear in this first step acts like an edge, and seems to flatten the fruit, despite the volume shown by the tone.

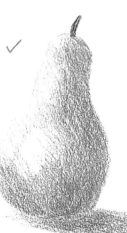

Pear with tone
This image is much more successful; the tone used to describe the fullness of the pear works well, and we are not distracted by hard outlines.

WATERCOLOURS – BASIC TECHNIQUES

Watercolours are excellent for colourful sketches, and provided you use sketchbooks with fairly thick paper, and do not create too many large puddles, any minor 'cockling' of the page will soon settle down. Here are some basic techniques.

Watercolour on dry paper
These shapes have crisp edges. To prevent colours mixing, leave space between the shapes and colours.

Creating a watercolour wash
You now have an area of 'wet', and colours placed side by side will 'bleed' into each other.

Mix colours 'wet into wet'
Do this by allowing the colours to blend together. Do not fiddle – let it dry naturally.

'Soft' edges
Add clear water, starting below the coloured wash and working up to it carefully. Use the belly of the brush and not too much water.

Broken effects

Stroke an almost-dry brush, loaded with pigment, in one direction across a textured watercolour paper surface.

Lifting out

Blot a wet wash with clean tissue to lift out the colour.

Straight lines or rectangles

Use a square, flat brush instead of the usual oval belly brush.

Using gouache

How gouache differs from watercolour: the top line is quite transparent – with plenty of water, gouache acts like watercolour. With less water (bottom line), it is almost completely opaque. Even when dry, the colour will lift when wetted again.

TONE WITH WET MEDIA

A suggestion of form is easily achieved when using water media or watersoluble implements. The simple method of applying clear water to a watersoluble line, will 'melt' the line and create an area of colour which will read as tone and will give the impression of form.

Watercolour added to a pencil sketch can help to add both interest and form, and may well provide a hint of drama to the sketch.

Creating form and tone
The circular form (top left) was created with a watersoluble graphite pencil. Clear water was applied to provide the sense of form. Watersoluble pens were used for the other sketches.

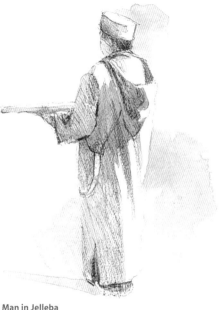

Man in Jelleba
15 x 10 cm (6 x 4 in)
This pencil sketch was created with line and pencil shading.
The addition of watercolour reinforces the form and provides
contrast to the back of the figure, giving a strong sense of the
light from the right.

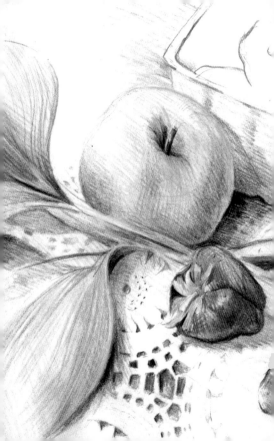

PART TWO

Developing skills

Your ability to produce a successful sketch depends on a number of factors. Learning how materials work is one element, and mastering the techniques using those materials is another. The third element – understanding some of the basic 'building blocks' of sketching – is perhaps the most important. It teaches us how to redefine the three-dimensional world and turn it into two-dimensional marks on paper. You need to know how to measure for sketching so your objects and scenes look right, how to show 3-D form, how to find new ways to represent what you see, how to translate tone into colour and work successfully with it.

Apple, Strawberries and Lace
20 x 25 cm (8 x 10 in)
When working in a sketchbook, it is fine to leave a sketch unfinished like this – it adds an element of interest.

MAPPING TONES

Three-dimensional form can be rendered with descriptive lines or with tones that show how light reveals form. Below is a drawing of an organic oval shape. It could be anything – perhaps a puddle – but when we add tone, as revealed by the light, we see the form emerge as a potato.

Potato
Drawing a potato is not difficult. As we saw earlier, a cube is even simpler because it is easy to see the changes of plane.

SUBTLE FORMS

If the form is more subtle and changes of plane more difficult to discern, mapping tones is a good way of analysing and simplifying what you see. Break down your subject into a simple arrangement of positive areas of tone value, ranging from light to dark. Allow five tones at most plus the white of the paper to see the subtle changes of plane. Squinting at your subject will also help, as will strong directional light.

1 With a 4B pencil, draw the basic apple outline without generalizing too much. Squint at the apple to see subtle changes of plane. Draw in the outlines of the main shapes you find.

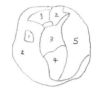

2 The 'key' image shows the tones: 1 is the lightest; 5 the darkest.

3 Cover the shape with one simple tone, leaving the white of the paper for the highlight.

4 Build up the tones, working through to the darkest one. Use cross-hatching to follow the apple's shape, curving your lines 'around' it to reinforce the form. Blend the outlines a little as here, or lift them with a putty eraser, or leave them showing.

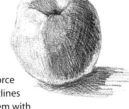

MEASURING

As soon as you start to draw any object, or a scene, you will quickly realize that although you might be able to represent a shape reasonably well, it is not always easy to get the proportions right. For instance, you may see that something is wider than it is high… but how much wider is it?

Always sketch 'free hand' first – this helps to develop your hand/eye co-ordination – and then you can use a simple ages-old measuring 'tool', as shown opposite, in order to check your drawing. When you are sure that your proportions are correct, you can finish the drawing with far more confidence.

Waterlily

If a shape is complex, you can simplify it by putting a box, in your mind's eye, around it before measuring. Put the edges of your box at the most extreme points of the shape.

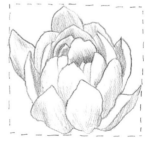

HOW TO MEASURE

Holding a stick or pencil, stretch out your arm, locking the elbow. Imagine there is a sheet of glass between you and the object, and press the stick up against the glass, perfectly parallel with your body. Do *not* point the stick at the object. Closing one eye, position the top of the stick against the top of the object and move your thumb down to the bottom of the object or shape you want to measure. This will be your unit of measurement. Keeping your thumb in place, elbow locked, move the stick down and see how many times that unit of measurement repeats.

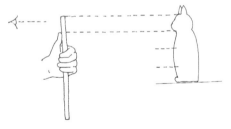

Getting the proportions right

This shows how the unit of measurement – the head of the cat figurine – fits three times into its body. It does not matter what size the drawing is as long as the proportions are correct. You can measure width against height in this way.

NEGATIVE SHAPES

Often we start at the top of a shape and draw around it, seeking out the *edges* of our subject, but this can lead to distorted proportions and inaccurate placement of shapes. One drawing technique that helps to train the eye is the art of seeing negative shapes, i.e. the shapes between and around objects.

SHARPEN YOUR OBSERVATION

When we look at the shapes between things, we are forced to be more observant. Instead of drawing a leaf – and falling into the trap of thinking we know what shape a leaf should be – we should concentrate fully to represent an unfamiliar shape with precision.

You should regularly practise drawings where you look more at the negative than the positive shapes in your subject. This will sharpen your powers of

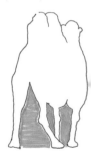

Camel

The shapes between the camel's legs help to describe the shape of the legs themselves.

observation and will prove to be a really useful tool.
The more you practise, the more it will become an
automatic method of double-checking your drawing.

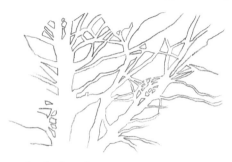

Drawing the shapes between

Find a suitable tree and draw only the shapes *between* the
branches and leaves. It is not easy to go back to the same
shape once you look away to draw, but it is fun to try!

Plant

The 'red lines' describe the
shapes between the leaves
and stems. Squinting at a
complex subject like this
groups leaves together.
Discovering shapes between
the groups is very helpful.

UNDERSTANDING COLOUR

Sketching with monochrome materials is fun but there may come a time when you want to work with colour, and learning something about colour theory will help you to use colours creatively as well as literally.

THE COLOUR WHEEL

The basic colour wheel (below) will help you understand why certain colours work well together. It gives us a specific arrangement of colours which will enable you to find, quickly and easily, complementary pairs of colour, and also colour harmonies.

Primary colours
The three main colours on the wheel are red, yellow and blue. These are called primary colours and they cannot be mixed from any other colours.

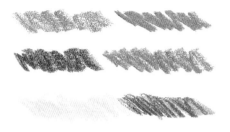

Complementary pairs

Opposite each primary colour (above) is its secondary, or complementary, pair, and each complementary colour is a mix of two primaries. When used together, complementary pairs provide the most colour contrast possible in a picture.

Colour harmony strips

Colours beside each other on the colour wheel (opposite), when used together, will give a very harmonious effect, and these strips show this idea at work.

TRANSLATING TONE INTO COLOUR

Everything in nature has a colour but that colour is often modified by the light. A red ball is light red in sunlight but dark red in shadow. If we express these tones incorrectly, our sketches will not be successful.

Judging colour tone

Learn how to judge the tone of a colour. Below are three strips – a monochrome tonal strip in the centre and two colour strips. The blue-green strip is easy to achieve – just work from light to dark – but choosing random colours is more difficult. Make a few of these strips, then photocopy them in black and white, to see how good you are at judging the tone of a colour.

Colour strips
First create a black and white strip. Then try to match the tones of the colours. Use a variety of colours rather than, say, a strip of blues or a strip of reds.

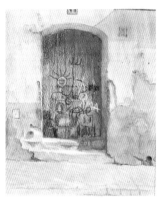

Graffiti Doorway
25 x 20 cm (10 x 8 in)
This quick sketch
was executed in
watercolour and
watersoluble
crayon.

Tonal version
Here we have the
same image again
but showing how
it would look if it
was photographed
in black and white.
It shows the tone
values of the image.

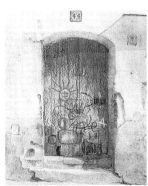

COMPOSITION

You might decide one day to produce a drawing which you will frame, or you may want to use a sketch as the basis for a painting. In either instance, you should consider the element of *design* which is just another word for 'composition'.

PLACING SHAPES

When you frame a picture, albeit a sketch or painting, it becomes something more than 'just a sketch'. The edges of the rectangle create a visual tension which makes the placement of shapes within the rectangle very important. Too much space around your subject and it might look dwarfed; too little space all around and it might look squashed. Shapes that are all the same size can look monotonous, while careless distribution can look chaotic.

Framing the picture
Here we have a viewing rectangle, cut from a piece of card. It immediately 'frames' the subject, enabling you to see how the image looks within a border.

COMPOSITION GUIDELINES

■ Use a viewing rectangle regularly (opposite). This will help you to get accustomed to seeing your subject within the edges of a rectangle.
■ Give your picture a title before you put a pencil to paper. Ensure that it is 'about' the title.
■ Try to see your image as a set of linked shapes, like a jigsaw, and see if the shapes look comfortable to you. Trust your instincts.

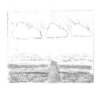

Good composition?
Does this look good to you? Or are the clouds and horizontal ground shapes monotonous, and is the position of the road rather boring? Learn to trust your instincts.

Balanced composition
This is a much better composition. The road shape is interestingly curved and leads us to the small houses that sit in a comfortable focal area. The cloud

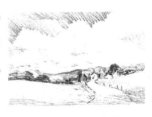

formation is cohesive and balances the picture well. There is two-thirds sky, and one-third land – a good balance.

THUMBNAIL SKETCHES

Before beginning a painting, do a series of thumbnail sketches to investigate a subject's design potential. Try tall, wide and square formats. You may be surprised to discover how one feels more right than the others. Squint at the subject to eliminate detail and concentrate instead on an overall design/pattern of light and dark shapes, with either the dark or light being dominant.

Different formats

Here we have two thumbnail sketches of the same scene. Having produced two, we can choose which one we like best. These are quite different in 'feeling' because of the change of format from landscape to portrait.

FOCAL POINT

Make sure your image has a focal point with good impact. As a guide, mentally divide the rectangle area into thirds, both horizontally and vertically, and place your focal point one-third of the way 'in' and 'up' (or 'down') from an edge. Draw the eye to the focal point with strong contrasts of either colour, shape or tone.

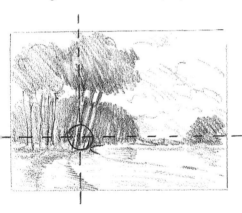

Locating the focal point
This small sketch shows the location of the focal point – the tree trunks light against the dark shapes behind. The eye sweeps in via the curves in the foreground to the focal point.

BEGINNING TO SKETCH

Sketching in the familiar and non-threatening
environment of your own home is the best place
to begin. You could start off by drawing everyday,
not-too-complex forms such as fruits and vegetables,
soft toys, or even sleeping pets as I have done here,
before moving on to trickier subjects with rigid
contours, such as crockery or machinery.

Sleeping kitten

A dip pen with liquid watercolours was used
for this very quick sketch of a sleeping kitten.

Soft toys
These are great fun to draw, as you can see from this odd
little creature which was sketched with a conté pencil.

QUICK DRAWINGS

Giving yourself a time limit – say, five minutes – to
complete a good practice drawing, since you are less
inclined then to fiddle with the details. Do your best
to observe shape and proportions as well as you can
in the time frame, and use these speed drawings as a
method of loosening up and acquiring confidence.

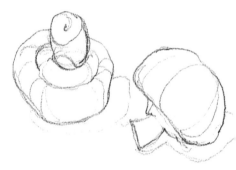

Mushrooms

It is fun to try drawing without lifting your pencil from the
paper, as I did with these mushrooms. I allowed my eye and
my pencil to make rhythmic lines, following the form of the
mushrooms. I permitted myself to go over lines more than
once to strengthen, and adjust the shape here and there. I
tried to see 'through' the mushrooms.

2¹/₂-minute sketch
Using a finger to
soften tone works
well with pastel
pencils, as shown by
this garlic bulb.

3-minute sketch
A paint tube in charcoal
pencil. Keep your touch
light, and do not use an
eraser – if a line or shape is
incorrect, simply redraw it.

5-minute sketch
I could now dissolve the colour, but I rather like the textures
of this crusty loaf which was worked in watersoluble wax
crayons – it looks like a crust.

ELLIPSES

You may well decide to sketch some man-made objects. Rectangular and square objects are quite straightforward to measure, but bowls or vases often have circular bases and openings, and there are certain things you need to watch out for, since a circular 'opening' is only circular when seen from directly above. From other angles, circles become ellipses, and you need to bear these points in mind.

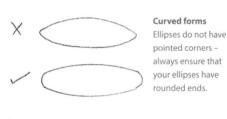

Curved forms
Ellipses do not have pointed corners – always ensure that your ellipses have rounded ends.

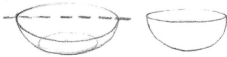

Checking the depth
Check the depth of an ellipse by comparing it with the width, measuring in the usual way. Seen from different angles, ellipses can vary greatly in width, as can the depth of a bowl.

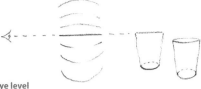

Eye level

Ellipses seen at eye level form straight lines. Above eye level, they curve down; below eye level, they curve up.

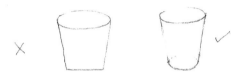

Curved bottoms

A common error is to give a pot, or vase, a straight bottom edge, just because it is sitting on a flat table.
The bottom must curve more than the lip

Checking your drawing

To check the drawing of a complex object, place a piece of tracing paper over your drawing; find the centre line, fold the tracing and see if both halves match.

SHARPER OBSERVATION

Allowing yourself as much time as you would like, try out some more careful drawings, where you explore forms and shapes really thoroughly.

Careful drawings, like the one below, where measuring is crucial and tones are studied hard, will help develop your skills. Every time you attempt something with this level of difficulty, even if the result is less perfect than you might like, you will build your 'muscles': eye and hand muscles. Accuracy and speed will develop in the fullness of time. Remember – practice is the key. Fill several sketchbooks to see real improvement.

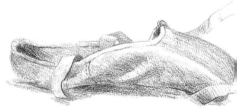

Ballet shoe

It does not matter how long it takes to do a drawing like this one in coloured pencil; what matters is that you look very carefully at all the shapes and tones, and try to represent them as accurately as you can.

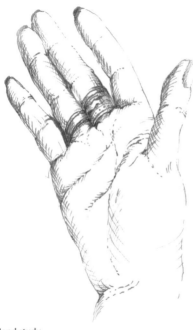

Hand study
This is a drawing I made of my own hand. As you can see,
I am left-handed!

Study of mushrooms

This careful study of three button mushrooms was done with a 4B pencil. Find some mushrooms that look like these and try this exercise. They make excellent models provided you do not spend days on a drawing or they will start to shrivel. Ensure that you have only one light source, from one side, as this will provide simple shadows, one lit side to each mushroom and a wonderful feeling of 3-D.

1 I drew the shapes freehand, using guidelines for placing the mushrooms and working out angles. I checked the proportions carefully, using my pencil to measure heights and widths.

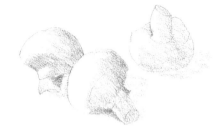

2 The main dark areas, which show the form, were roughed in with the side of the pencil lead and using gentle strokes.

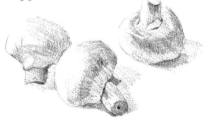

3 Finally, I studied the mushrooms hard, using tone and linear strokes to describe their form, and some darker lines for a few sharply defined edges. Notice how there is no 'outline' all around the edge, only on the light side – there is no need to draw a line all around. I checked the tones by comparing one area with another, asking myself: 'Is this area darker or lighter than that one? How much darker/lighter?'

WORKING TO A THEME

Hone your powers of observation by working to a theme rather than drawing objects in isolation. The more you draw a set of objects, the more familiar they will become, and the more you will understand what you are drawing. When working at home, vegetables and fruits are an obvious 'theme' but there are others, too:

- Different kinds of cushions, pillows, boxes or bags.
- Sets of saucepans.
- Different shapes of jugs or bottles, tins or packets.
- Clothing draped on chairs or hanging from hooks.
- Chairs, armchairs and stools.
- Shoes and boots, various shapes and sizes.
- Breads and rolls.
- Shells.

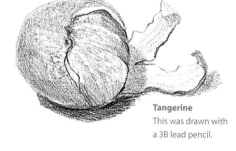

Tangerine
This was drawn with
a 3B lead pencil.

The more you think about it, the more themes you will find. My theme here is cut or peeled fruits, beginning with some simple pencil drawings and working up to colour renderings.

Cut pear
Charcoal pencil was used with a torchon for blending.

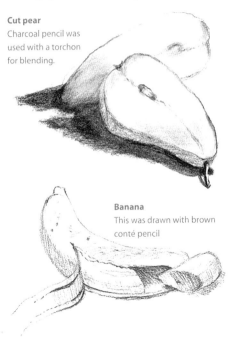

Banana
This was drawn with brown conté pencil

Apple pieces
A dip pen was used
with concentrated
watercolours.

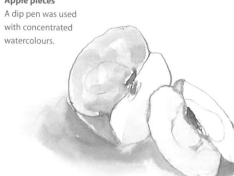

Strawberries
Pastel pencils
were used for
this sketch.

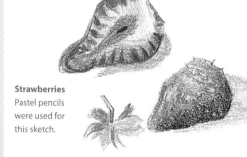

Cut grapefruit using coloured pencils

1 When using coloured wax pencils, it is best to start with your lightest colours, and keep your touch light.

2 Try to achieve a good sense of the 3-D form before increasing the pressure for stronger colour and adding tiny details. Build up the colours gradually.

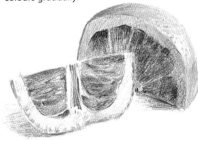

SKETCHING FROM THE MASTERS

One of the best ways to learn about drawing is to copy a Master drawing. I do not mean a rough copy but a detailed one where you faithfully try to emulate every line and tonal area. You will discover why the artist was called a 'Master'. Hardly a line will be random, hesitant or fiddly. You will see how the artist used line and tone to describe form properly, and if you copy a figure, you will see how well he or she understood anatomy, too.

Find a drawing or sketch that you would like to copy and then trace the main outline. Transfer your tracing to a sheet of paper and then carefully copy the drawing. Use the same medium that was used by the Master.

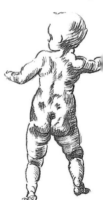

Cherub

I have used a Michaelangelo 'cherub', originally executed in pen and ink. I used a dip pen and brown ink. See how not only the outline of the figure describes its plumpness. The lines used for the shading of the figure all 'go' in particular directions, emphasizing the fullness of the form.

When you have done several 'transcriptions' of master drawings, keeping to the original medium, you can try one or two using a different medium but maintaining a similar finished effect. So, if the original medium was charcoal, you can use red conté or chalk pastel; if it was pen and ink, you can use pencil.

I have copied a study of drapery in 'black crayon' by Dominique Ingres (below), using sepia conté on its side to create areas of tone and get a similar effect.

Original outline drawing
This was taken from the tracing. Because I was being slow and careful, there is a stiffness about this stage.

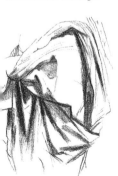

The finished effect
This is much freer, and less stiff, as I gained confidence and used swifter strokes.

THE COLOURED SKETCHBOOK

There are many sketchbooks with coloured pages on the market. They can be multi-coloured or one colour throughout. The colour can act as a 'middle tone' for your drawings. For a monochrome effect, one colour – charcoal or conté – can be used together with a white stick of conté, and the finished drawing will have a range of tones from very light to middle tones, which will include the colour of the paper, through to your darkest marks. A full colour sketch or drawing can obviously also be created on a coloured ground.

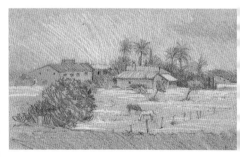

Mallorcan Farm
20 x 37 cm (8 x 15 in)
This rustic farm was sketched in pencil and white pencil on a coloured recycled paper pad.

If you like the idea of using charcoal, pastel, or any dry, dusty medium, look out for sketchbooks with tissue interleaves, which will protect your work from smudging. Otherwise, you must use spray fixative.

Watercolour paints, with the addition of opaque areas of gouache, also work well on a coloured ground. You can use your regular watercolour paints, together with a tube of white gouache, to create milky, opaque mixtures for a gouache sketch.

River and Snow
10 x 20 cm (4 x 8 in)
This wintry study was done with pen and white conté on a grey pastel paper pad.

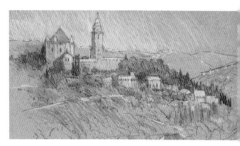

Mount Zion, Jerusalem
25 x 37 cm (10 x 15 in)
A red felt pen and white conté crayon were used here.

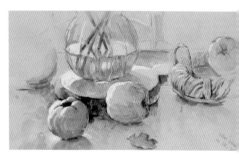

Godonias in the Sunshine
20 x 27 cm (8 x 11 in)
Pencil, gouache and watercolour were used for this sketch.

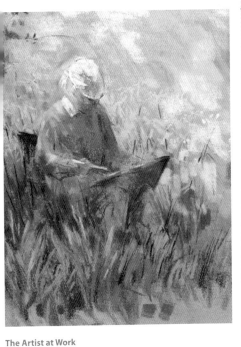

The Artist at Work
25 x 20 cm (10 x 8 in)
This moody sketch was executed with pastel pencils in a
pastel paper coloured sketchbook.

SCALING UP FROM SKETCHES

There are times when you produce a great sketch which you want to use as the basis for a painting. If you transfer your sketch to the painting surface in the wrong proportions, you will find yourself in trouble very quickly. So it is best to ensure that the proportions of your sketch are identical to the proportions of your painting support. You can then use one of several different methods to transfer the details of your sketch to your painting surface.

SIMPLE METHOD

To scale up simply and easily, without removing your sketch from your sketchbook, place a sheet of tracing paper over your sketch and draw around the outside edges of the shapes in your sketch.

Checking proportions

Place the tracing paper on the corner of your canvas or paper. Run a straight-edge from corner to corner of your drawn rectangle. Extend it as far as you want to create a large rectangle.

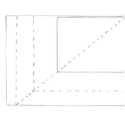

If you wish to transfer the main elements of the sketch to your support, as accurately as possible, replace the tracing paper over your sketch, and draw over the main elements of your subject. Then draw a series of squares over the top, and on your support mark out the same number of squares. The proportions will automatically be correct because your support is in the same proportion as your sketch.

Now you can easily transfer the main elements of your sketch to your large canvas, and they will be perfectly in position. It is best not to transfer too many tiny details at this stage or your transferred drawing will be rather stiff and you will end up 'colouring-in'.

Transferring a sketch
Use a grid of squares to transfer the main elements of a sketch to your support. This is easy and accurate.

WORKING WITH PHOTOS

Taking a photo lasts only a second or two and fixes an entire scene at a particular moment in time. However, the worst thing you can do is to simply copy a photo. The camera provides every detail, and you will have the time to include all that detail but, as a result, your sketch will not look spontaneous.

USING A CAMERA

Use a camera to back up your sketches and provide additional information that you may not have time to capture on the spot. This is good for figures; you can add them to your sketch later with confidence.

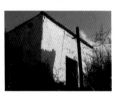

Back-up photo for sketch
This photo alone would have been rather uninspiring.

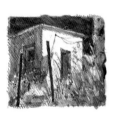

Sketch done on the spot
See how much more colour and interest there is in the sketch than the photograph.

Photos can be used as starting points for sketches or paintings, particularly if you combine several elements from different photos to create a newly-composed image. Try to condense and revise the information they provide. Cut out superfluous details to capture the essence of a scene. Giving yourself a time limit will help. This is the same discipline you would use when sketching on location. This will make using photographs a more satisfyingly creative experience.

Shepherdess with goats
This photograph was taken on location in Cyprus.

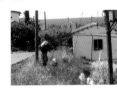

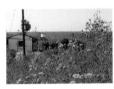

Second photo
This was taken at the same location for more information.

Sketch on the spot
With this sketch and the two photos I had sufficient information to paint this picture back in the studio at a later date.

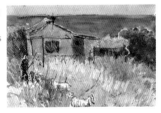

USING A COMPUTER

Computers can be very useful 'artists' tools'. It is quite easy to copy a sketch, for instance, by scanning it into your computer's memory, and then you can resize or alter it on the screen. You can print out various versions of your sketch in different sizes, leaving your initial sketch intact. You can try adjusting tones and colour, and even the content of the image – you can remove parts that you feel need to be changed, or crop the image to see how it might look if you plan to use it as the basis of a painting.

PHOTOGRAPHS

These, too, can be stored in the computer's memory before being edited and adjusted to make them more suitable for use. Changing a photograph to 'greyscale' means that you could use a monochrome version of the photo as a starting point for a new image in totally different colours.

The 'greyscale' function on a computer is also an excellent way to check the tone values in a coloured sketch. Using a photo editing programme takes some practice but it can be great fun and can open lots of interesting doors for you.

Jerusalem view
This is my original
sketch.

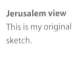

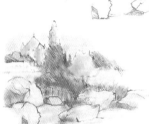

Photo colouring
The sketch was
photo-coloured
in a photo editing
programme.

Cropping the sketch
Here the sketch has been
photo-coloured, then
cropped to a vertical
format to examine an
alternative composition.

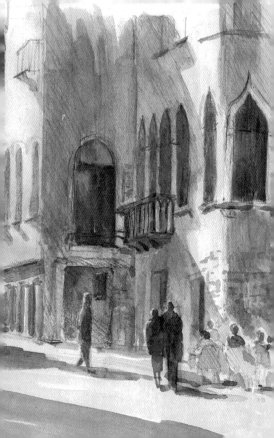

PART THREE

Subjects

We have come a long way in our journey and have reached the stage where the world is our oyster in terms of subject matter for sketching. Subjects are everywhere – from the simplest still life to complex and dramatic landscape scenery. However, the best subjects are often those we fail to notice: crockery on a draining board; an unmade bed; a pile of broken flowerpots in a garden corner; the broken fence we have to fix and have tried to ignore. A sketch done every day is the best way to learn and improve, and, hopefully, in the following pages you will find some ideas and inspiration.

Dorsoduro Street Café, Venice
30 x 20 cm (12 x 8 in)
Tucked into a small corner in the shade, with my back to the wall, I was able to sketch this scene without being disturbed. I used a small sketchbook and my pocket watercolour kit, flooding colour over a pencil undersketch.

PLANTS AND FLOWERS

Flowers and plants provide endless variety for close study as well as wonderful colour notes in a landscape or garden scene. For close observation, cut flowers or flowers in pots, in constant light conditions, will give you every opportunity for careful observation. However, do bear in mind that flowers will change daily – cut flowers will gradually open and then will wither and die, whereas flowers growing in pots will change shape as they open more fully. Learning to work with some sense of urgency is quite important!

You need to learn to choose colour schemes carefully when you are tackling areas of garden flowers so as to avoid a kaleidoscope of indiscriminate colour.

Hanging basket

I quickly sketched this hanging basket with hard pastels. Small dots, dashes and tiny marks were used to give the impression of the masses of small flowers and leaves. A lively effect can often be achieved by working freely and swiftly.

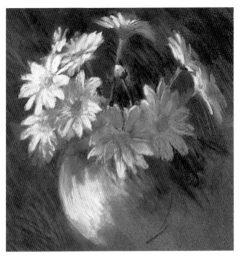

Daisy Study

15 x 12 cm (6 x 5 in)

This small study of flowers in a white bowl is an unfinished sketch in pastel pencils. The dark ground provided a good strong contrast to the light tones of the flowers and bowl.

It is very helpful to learn how to simplify swathes of growing flowers and foliage in order to give the impression of flower masses.

WHAT SHALL I WORK WITH?

This garden corner is a mixture of plants and flowers. While it may be more comfortable to work with cut flowers indoors, and it is a good way to study flowers at close quarters, it is still rather nice to have the 'background' of a garden to sketch.

Pencil

This was done with a 4B pencil. Because there is no colour in the sketch, it was a question of deciding upon the light, medium and darker tones to use. Lots of close diagonal strokes were used for tonal shading. Notice how the tonal areas are 'blocked together' – if you squint at a scene, it simplifies into its main tonal areas.

Pen and ink

This sketch was created with Dr Ph Martin's Concentrated Watercolour, which is just like ink. I used a dip pen, and by making short and long strokes, together with looser, more organic scribbly marks in places, I was able to suggest the fullness of the form of the flower heads and the shapes of the leaves and flowers in both the foreground and background. Swiftly applied gestural marks like those at the bottom right give a lively feeling and add the impression of movement.

Brown conté pencil
The feeling of light breaking across from the left was
emphasized by blending the pencil strokes with a torchon.
This not only provides a good explanation of the three-
dimensional forms of the plants but also gives a lovely soft,
hazy effect which is quite different in atmosphere from a pen
or pencil drawing where cross-hatched tone is used.

Watersoluble pens

Finally, a move into colour. Watersoluble pens were used for this quick sketch. Once applied, they were 'melted' with a damp brush, and when the sketch was dry, more short choppy strokes were added to the greenery in the background to suggest some foliage, and tiny lines were added to the crazy paving.

CLOSE STUDIES

When sketching flowerheads, look for the underlying geometric shape to give you a good starting point. Daffodils and lillies are trumpet-shaped; roses and camelias are cup-shaped; and daisies are circular or arc-shaped. Remember that flowers do not always present you with one view – they twist and turn to follow the sun, changing their shape as they do so.

Lily shape

This is the basic geometric shape of the lily – an open 'trumpet' shape. Before beginning your flowerhead, carefully measure its width and compare it with the depth. A great deal depends on how open the flower might be.

Lily sketch

I used a watersoluble green pencil, shading the areas of petal which were turned away from the light to give a sense of form. With a damp brush, I then 'loosened' the pencil shading and softened some of the lines.

Flowers are soft and fragile, and petals should not have hard lines like wire around them. Close observation is the key – try not to generalize just because you 'know' what a daisy, or a daffodil, looks like. Treat each flower head as you would a portrait and aim for some fluency in the drawing.

Leaves, berries and buds

These are fun to sketch and will give variety to your drawings. Look for direction of growth, observe how buds and leaves attach to stems and try to capture the variety in textures. Different media give different effects.

Catkin buds

These soft furry buds were captured with tiny strokes of black conté. See how the untouched areas of paper read light against the dark stem.

Leaves

Pen and ink is not the easiest of media but the linear strokes show the direction of growth. See how they curl round the form to show the shape of the leaves. Dark tones can be built up with cross-hatching.

GARDEN FLOWERS

Garden scenes are tempting to sketch, particularly in colour. To prevent sketching a mass of coloured dots, which is not visually interesting, it helps enormously to squint in order to simplify the scene and mass together groups of flowers. Try to keep your colour choices fairly simple to begin with – two or, at most, three main colours will work well, whereas lots of

Border sketch

Clean water was applied to watercolour paper and some colour 'dropped in' to the centre and allowed to dry as a soft-edged wash. Pastel pencils were used for the drifts of flowers, with short stabbing strokes to suggest blooms, longer stroke for stalks, and tiny circular scribbles for leaves. The texture of the paper breaks up marks and adds to the level of suggestion.

different colours sketched in a random fashion can look rather hectic. It is also a good idea to give yourself a time limit, so that you stop before you start to add in unnecessary fiddly detail. Try to keep your sketches fairly free and lively, using dots, dashes and scribbles to suggest areas of flowers.

If you use pastel pencils, as I have done in the garden border sketch below, do remember to spray fix the sketch if you do it in a sketchbook.

Penstemon Border
12 x 17 cm (5 x 7 in)
This was sketched on the spot in pencil and watercolour in the gardens of a Scottish castle.

WILD FLOWERS

You may think that most wild flowers grow in a totally random fashion but, in fact, mother nature is far more colour-coordinated than most humans. She regularly selects 'complementary colours', or 'colour harmony', for her colour schemes, as you will discover if you venture outside your garden to sketch some seasonal wild flowers in parks and fields.

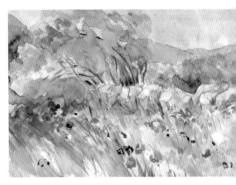

Wild Flower Field
15 x 20 cm (6 x 8 in)
Watercolours were applied quite freely over an initial pencil drawing to give an impression of wild flowers. Fine linear brush strokes show the growth pattern of the tree.

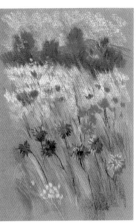

Blue Thistles
17 x 10 cm (7 x 4 in)
Massive blue thistles
grow in profusion in
northern Israel – quite
a sight to behold. This
quick sketch was done
with pastel pencils in a
coloured sketchbook
and was produced in
order to see how a
large painting of the
scene might look.

In late spring, bluebells grow in carpets of wonderful
colour harmony – blue, blue-purple and purple-pink.
Wild golden-yellow narcissi will often be surrounded
by clusters of tiny purple flowers. Red poppies will
blaze in grass and cornfields alongside tiny white
flowers and will be complemented by swathes of cool
green. Purple-blue thistles will be partnered by small
yellow-orange wild flowers. I am not an expert with
the latin names but I never fail to be impressed by
nature's ability to compose with colour. We artists
can learn a lot from her.

LANDSCAPES

When you feel brave enough to venture out into the landscape with your sketchbook, you will discover an entirely new world. The shallow depth of a garden scene is quite different to the space in a landscape view. Now, you have to deal with foreground, middle distance and distance. Your choice of subject-matter will be enormous, too – a meadow is a landscape as is a woodland scene, a mountain scene or a vineyard.

Your viewfinder will be indispensable because the landscape is all around you and you need help with selection. It will contain changing forms like clouds or

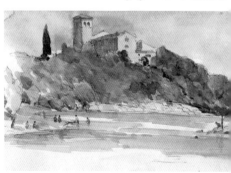

wind-blown trees, giving
sketches produced on the
spot a particular vigour,
freshness and spontaneity.

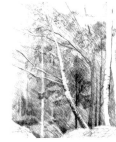

Silver Birch Woods
25 x 20 cm (10 x 8 in)
Black conté pencil.

French Lake
37 x 10 cm (15 x 4 in)
Although this looks like a large watercolour painting, this
sketch in pencil and watercolour stretches across the pages
of a narrow sketchbook. Working on this scale, there is no
need to worry about stretching paper.

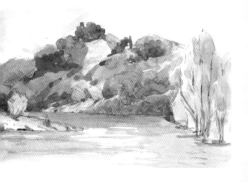

WHAT SHALL I WORK WITH?

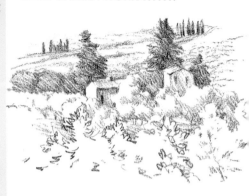

Carbon pencil

This monochrome sketch was done with a carbon pencil. Not unlike charcoal, it produces a lovely soft effect when used on its side, and yet the point will give firm, dark lines. Carbon pencil will smudge, so if you work in a sketchbook do 'fix' your drawings to prevent transfer of the marks to the adjoining page. Also, as you work, be careful not to smudge your drawing with your hand.

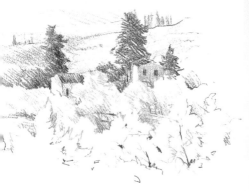

Watersoluble coloured pencils

This was done with watersoluble coloured pencils, left undissolved. The marks in the foreground, which are simple scribbles, read as trees and add a touch of liveliness to what might otherwise be an ordinary coloured sketch. By overlaying one colour over another, using cross-hatching or other linear marks, interesting mixed colour effects can be achieved. Press lightly to begin with, and build up the pressure slowly and gradually.

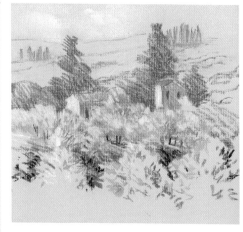

Pastel pencils

This sketch was made on pale green pastel paper with a slight texture. Pastel pencils were used for the sketch, and the marks were broken up by the texture of the paper. Touches of white pastel over green were perfect for suggesting silver-leaved olive trees, which are so difficult to capture in colour.

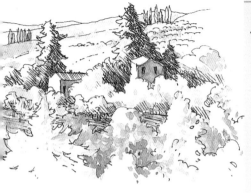

Pen and watercolour

Here we move from monochrome into a touch of colour, with
a brown pen sketch and touches of watercolour in ochres and
blue-greens over the pen lines.

CREATING DEPTH

One very important aspect of working out of doors, particularly when you're tackling landscape scenes, is learning how to create a sense of space and distance. A distant tree, for instance, is no less green than those close to you but, visually, its appearance is quite different. It will look lighter in tone, cooler in colour temperature, and will appear to have softer edges.

Aerial perspective

There are times when foreground objects are cool and background areas are warm. All rules are made to be broken and we need to use careful observation.

Landscape sketch
This quick sketch was done with watersoluble pencils, which were dissolved with a damp brush.

However, as a general rule of thumb, as we move back in space, tones become gradually lighter, contrasts less strong, and colours less distinctive, as a result of the subtle veils of atmosphere – vapour and dust particles – between the artist and the distance.

Change of scale and overlap

Two other elements of drawing will help you achieve a good sense of space in your sketches. Distinct changes of scale will help to emphasize the illusion of recession, whereas exaggerating the overlapping of forms will clearly imply that one form is in front of another.

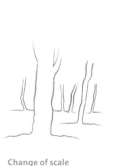

Change of scale
This can be used to imply distance in drawings.

Overlap
This works better than 'kissing' shapes (top).

LANDSCAPE TEXTURES

A landscape drawing or sketch may not always have great depth and distance in it; in fact, an 'intimate landscape' scene with shallow depth of foreground only, or just the foreground and middle ground, is a perfectly valid subject.

Translating what you see

However, when we draw more intimate landscape scenes, we are closer to our subject matter, we 'see' more detail, and we need to find a way to translate what we see. A tree, seen in the summer, will have thousands of leaves. A camera might capture every leaf but we artists need to find a way to 'suggest' foliage or we will be drawing that tree for months!

We need to develop a language of 'descriptive marks', which will help to suggest landscape elements; marks that will represent rather than reproduce landscape features. The following pages offer just a few ideas of my own, but in time you will develop your own range of richly descriptive marks to suggest the textural qualities of the landscape. Remember that different media will provide different effects, so do try to be spontaneous and experiment playfully in order to add to your repertoire.

Foliage

The 'brush tip' of a fibre-tipped pen creates scribbly marks to give the impression of leaves.

Grass

Short stabbing strokes with different coloured pencils give the impression of tufted grasses.

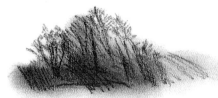

Distant trees

Small linear strokes of black conté pencil, rubbed with a finger.

Suggested blocks

Small chunks of black crayon are used on their side.

Stony riverbed

A dip pen is used with Dr Ph Martin's Concentrated Watercolour for dots, dashes and circles, which dissolve in a water wash.

Long grasses

Used with vigorous sweeping linear strokes, a pencil gives movement to long grasses.

Drystone walls

Watercolour washed over pencil marks and shading gives the impression of the rough drystone walls which are often found in the landscape.

TREES

Whether a tree is the main subject of a landscape scene or just a tiny part, it will always give a sense of life and growth to a scene. Trees have character, and capturing that character should be your aim.

Winter trees

When deciduous trees shed their leaves in winter, you have the perfect opportunity to study the structure of trunks and branches. You can simplify what you see by drawing only the main shape and parts of the structure, and by trying to capture the pattern of growth. Do not be tempted to generalize. Try out different viewpoints, since lots of branches reaching out towards you will present you with foreshortening problems.

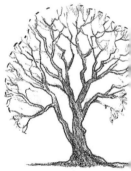

Winter tree
This careful, slow sketch was made in 4B pencil to investigate the growth of a winter tree.

Side lighting is always helpful to define the shapes of branches and trunks, but make your marks 'wrap around' the form. If you sketch the base of a tree, notice how the shape widens as it meets the ground.

It is good to remember that branches become smaller in diameter in stages, and each branch sends off another branch which is even narrower, which in turn sends out twigs which are thinner still. Draw what you *see*, not how you think it should be.

Describing form
The brown conté pencil marks 'wrap around' the branches, describing the form.

Fluency
This winter tree is much more swiftly sketched with a conté pencil. It has more 'fluency' than the drawing above, but it still shows good observation.

Summer trees

Clothed in foliage, summer trees are glorious to behold but if you try to sketch every leaf you will soon come unstuck. Search out the main shape of the tree, which will show immediately what kind it is. Look for the three-dimensional form of the foliage clumps, best sketched when the light hits from above and slightly to one side. Back lit, or forward lit, trees present as silhouettes. Trees grouped together often form one larger shape with lots of trunks. Finally, provide some filigree 'holes' in the foliage for the sky and for branches to show through; they will keep the tree looking natural.

Sketching the outline
Begin with the trunk of the tree, the main visible branches and the clumps of leaves.

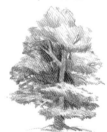

Adding the tones
Tone values give a good sense of light for sunlit areas, midtones for foliage, and dark depths. Keep edges loose and feathery to suggest the softness of foliage.

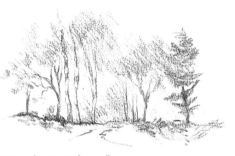

Group of trees seen from a distance
Branches melt into areas of tone, but it is still possible to discern different tree types because of the shapes of the marks.

Leaf shapes vary considerably: fir tree foliage is very different from oak tree leaves. Aim to hint at the leaf shapes through the kinds of marks you use – hatching, shading, spiky dots and dashes, and curving marks.

CHECKLIST FOR SUMMER TREES
- Squint to simplify.
- Lightly suggest the overall tree shape.
- Indicate the main clumps of foliage.
- Look out for dark branches against light foliage, or light against dark.
- Keep the angle of the light consistent.
- Consider the mark you need to suggest foliage type.

SKIES

You have to work fast when sketching the sky – clouds are blown about by the wind and change shape. Build your confidence with monochrome sketches in soft pencil, conté or charcoal before moving into colour.

Quickly find the main outline of the largest clouds and observe how the light reveals the three-dimensional forms of full-bodied cloud formations. Keep the edges soft and varied. Gradually introduce smaller, subsidiary clouds. The shadow on a cloud will usually be on the side furthest from the light source – the sun – but try not make your shadows too dense and heavy, since light can shine through cloud vapour.

Clouds with conté pencil
Begin with the outlines of the clouds, and use tonal side strokes for the sky between the cloud shapes.

Suggesting fullness
Use your finger to soften and blend the 'blue' sky. For the cloud shadow sides, use short curving strokes to suggest the fullness of the cloud.

A backlit cloud, with the sun behind it, will not only have a 'silver lining' but the sun will shine through it in places, making it look almost translucent. Look for interesting focal points – a dark cloud against a pale patch of sky, or a sunlit edge, for instance.

Working on blue paper
Scudding clouds can be suggested with a white pastel. Press hard for thicker clouds; blend for softer edges and more suggestion.

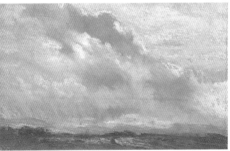

'Silver lined' clouds
Grey, orange, white and cream pastels were used on orange-coloured recycled paper. The rough quality of the paper breaks up the pastel and gives a nice texture in places.

Linear perspective

Both the sky and clouds recede from us, just as the land does, and if we make use of perspective 'rules' as they apply to clouds and skies, we will achieve a sense of space. The clouds above you are closest to you and are the biggest ones; those at the horizon are the furthest away and appear much smaller. This is 'linear perspective' and it gives a wonderful sense of space. As they recede away from us, clouds often overlap each other, and this helps to create an even greater sense of space.

Aerial perspective

Study the blue of the sky: it is darker and more 'purple' above your head, and lighter, cooler and more turquoise towards the horizon. This is the result of 'aerial perspective'. Study the horizon carefully: often the sky has hints of cream where it meets the land.

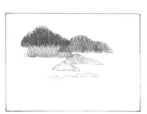

Creating a sense of space

This is shown here in diagram form by havin stronger, darker cloud at the top, and tiny, pa clouds below, togethe with overlapping form

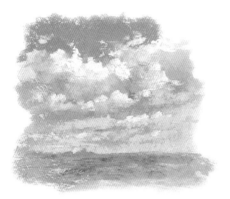

Sky Study

22 x 27 cm (9 x 11 in)

This was made with pastels on coloured paper. The change of scale in the clouds emphasizes the feeling of space and distance.

Blue of the sky

Done with pastels on white cartridge paper, this shows how the vastness of the sky is emphasized with aerial perspective – dark blue sky overhead, gradually lightening toward the horizon.

Colour in clouds

Clouds may appear to be white or grey but which grey? Blue-grey? Purple-grey? Pink-grey? And is the white pure white or is it tinted with the warm colour of the sun? At different times of day and in various weather conditions, different, and often very dramatic, colour effects take place in the sky, and it can be fascinating to record what you see.

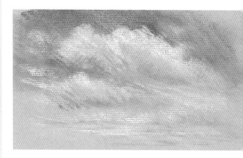

Summer Clouds
10 x 17 cm (4 x 7 in)
Pastel pencils were used for the blues in this sky on heather-coloured pastel paper, leaving gaps for clouds. White and cream pencils created the sunlit tops of the clouds, and pink-lavender and cream were used for the underside shadows, using cross-hatched strokes, which were softened in places with a finger.

Coloured pencils and watersoluble media are good for making colour studies in white sketchbooks; pencils and sticks of pastel work well on coloured pages. Small watercolour sketches can be very satisfying, painted quickly with a limited palette.

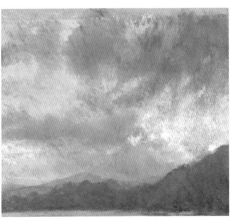

Storm Clouds

37 x 50 cm (15 x 20 in)

Worked with pastel on a coloured ground, these clouds were sketched with purples and purple-greys, while the light in the sky was created with a cream pastel. Used on their sides, even hard pastels will give a soft effect, which is perfect for clouds.

SHADOWS

Shadows can bring a sketch to life, providing interesting tonal shapes which contrast with light areas. They not only describe the fullness of form and changes of plane but also usefully anchor objects to the ground.

It is important to realize that shadows created by sunlight move all the time. As the sun moves higher or lower in the sky, they will shorten or lengthen, and sometimes may even disappear. The sunshine illuminating one side of a bush in the morning may well illuminate the other side in the afternoon.

Shadow guidelines

■ Note the direction of the light when you begin to sketch, and try to capture the position of shadows quickly. Ideally, do not spend more than two to three hours on a scene with lots of shadows because they will change too much after that.
■ Make sure shadows follow the contours of what they fall upon, dipping into hollows, rising over bumps.
■ Notice how the ground colour will show through a shadow, and see how colours from the surroundings will reflect into and influence the shadow colour. See if the colour and tone of the shadow changes along its length.
■ Study shadow edges. Some are quite hard and dark, particularly when objects are very close to each

other; other shadows have very soft edges.

■ Because shadows are amorphous, it is tempting to generalize. Do study shadow shapes and sizes.

■ Shadows are subject to linear perspective – they converge and narrow as they recede from the viewer, while aerial perspective will make distant shadows lighter than those in the foreground.

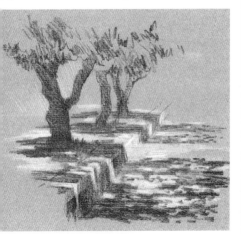

Path with dappled tree shadows

A two-pencil sketch like this in brown and white pastels on coloured paper provides immediate impact.

ANIMALS IN THE LANDSCAPE

Animals can add a sense of movement, life and interest to a scene, together with touches of colour. Sheep, cows and goats in meadows will contrast with their surroundings and often group together to form interesting shapes within the landscape. Dogs, cats, hens, geese and ducks – these all make wonderful subjects to enliven a landscape scene.

Practice and patience

You may need to spend some time practising drawing animals in order to become familiar with their particular shapes. Animals have a habit of moving when we watch them, so we have to draw quickly and

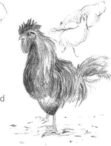

Cockerel
Coloured pencils were used to capture the cockerel's finery. The chickens in the background did not stand still, so I had to settle for capturing their basic shapes. A camera can be very useful in these circumstances!

simplify their silhouettes before adding any details. Be patient; if your subject moves, it may well return to that same pose again, so start another sketch on the page of your sketchbook, and return to the first sketch if the opportunity arises.

Trio of sheep
This quick sketch in graphite pencil captures the amusing shapes and character of this trio of sheep sitting patiently around a tree.

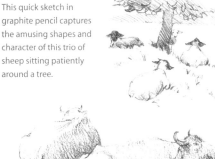

Indian bullocks
In a dusty corner of India, these bullocks sat quietly while I sketched them with a 4B pencil. I aimed to capture their unusual silhouettes first, and then added tonal shading.

URBAN SCENES

The urban landscape presents us with new challenges: sketching buildings and architecture. Although some artists produce stylized sketches with deliberately wonky buildings, if you want to draw a building accurately, you must learn about linear perspective, but this is not as hard as you think. Then, you can have fun with buildings, street scenes, architectural features and the man-made textures to be found in villages and cities.

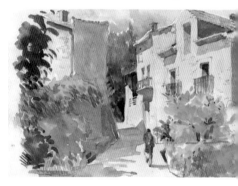

French Village
20 x 40 cm (8 x 16 in)
A pencil and watercolours were used to create this scene.

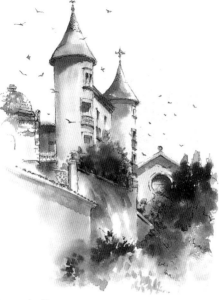

Languedoc Towers

25 x 20 cm (10 x 8 in)

I began with a very light pencil sketch to get the perspective, and proportions right. I then worked with a dip pen and concentrated watercolour. Finally, I used a brush to flood the drawing with the same watercolour and turn it into a monochrome sketch. The wheeling birds were a bonus!

WHAT SHALL I WORK WITH?

Pencil

Working with a soft 4B pencil on cartridge paper gives a good range of tones from very light to very dark. Sharpen the pencil to a long point and be prepared to use the lead on its side to achieve soft tonal areas. Remember that shadows move very quickly in an urban location so try to work swiftly.

Watersoluble coloured pencils

The texture of the watercolour paper broke up the layered pencil marks, creating a textured effect. When the sketch was completed, some areas were softened carefully with a brush that was just damp, and scrapings of colour were dropped into wetter areas to add to the textural effect. Sharp details were added over the dry, finished piece.

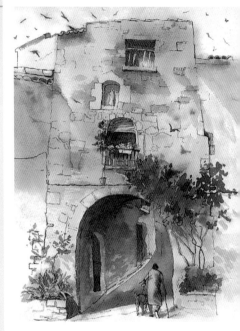

Dr Ph Martin's Watercolours
Linear pen work suggests wall bricks; darker cross-hatched areas
were created under the archway. A brush was used for the
washes on the walls and for the foliage, building up the layers.

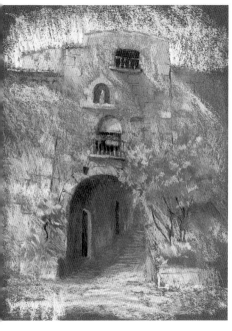

Hard pastels

The sides of the sticks gave areas of colour, and the chisel ends greater precision. A piece of sharpened charcoal was used to delineate the edges of some of the bricks in the walls.

SKETCHING BUILDINGS

Here are a few helpful tips which relate specifically to sketching buildings.

■ Always begin with the largest shape of a building before putting in doors or windows. Work from large shapes down to small ones.
■ Always mark your eye level on your sketch, to ensure that your angles travel in the right direction – down, from above eye level, and up from below eye level.
■ Hold out a pencil vertically or horizontally to scan across a building in order to line up details.
■ The shape of the sky is often a good starting point to a drawing of a group of buildings or a street scene. Get the sky shape right, and the building edges will drop down naturally from the roof line.

The sky
Becoming aware of the sky as a shape in its own right, is often very helpful. You can drop lines down from corners and edges.

PERSPECTIVE

Even the word 'perspective' terrifies most beginners, but do bear in mind that once you understand the basics, you need only use perspective rules to *check* what you have already drawn.

Eye level

Your 'eye level' is the horizon. Whether you sit or stand to work, your eye level is a horizontal extension of your gaze. Hold your pencil across the bridge of your nose – it will run across your eyes. Look out across it and *that* is your eye level.

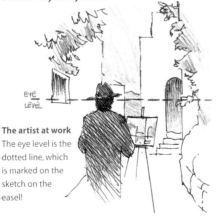

The artist at work
The eye level is the dotted line, which is marked on the sketch on the easel!

Basic perspective rules

■ All lines running away from you, above your eye level, will run *down* towards your eye level.
■ All lines running away from you, below your eye level, will run *up* towards your eye level.
■ Horizontals and verticals will remain unchanged.

One-point perspective

Here is an example of one-point perspective, which normally applies when the lines of, for instance, a wall to your right or left, or a road beneath your feet, meet at a single *vanishing point* on your eye level.

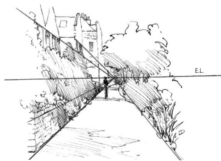

One-point perspective
See how lines above the eye level drop down to the vanishing point, while those below it rise to meet at the vanishing point

wo-point perspective

his occurs when we can see two sides of a building
r a table, or a carpet etc). There will be two vanishing
oints on the eye level, one each side of the building.

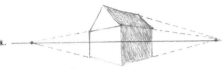

wo-point perspective

he eye level remains horizontal, but there are two vanishing
oints. Remember, it is important to have the proportions of
e building correctly established before you extend your
erspective lines to check perspective.

hree-point perspective

his occurs when we look up at a tall building from a
oint close to the base, or if we look down on a structure
om above. A third vanishing point will
ccur above or below the building.

hree-point perspective

is not often that one has skyscrapers
draw, but if you do chance upon
ne, these rules will apply!

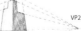

Perspective centres

It is important to be able to find the centre of shape which is seen in perspective. This will help you to locate, for instance, the position of a gable roof or a central window or doorway.

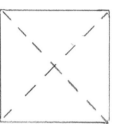

Finding the centre
Finding the centre of a square, or rectangle, is simply a matter of drawing lines from corner to corner.

At an angle
The centre of the same rectangle, seen at an angle, is 'off-centre'. Use the same principle of drawing lines from corner to corner to find the centre. Extend the centre point upwards to find the tip of the gable roof.

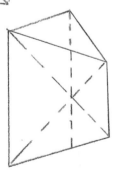

Archways

Measure height against width, and draw a rectangle
around the arch, in perspective. Draw the perspective
centre and ensure that the top curve meets the
perspective centre of the rectangle.

1 2 3

Drawing archways

1 Archway facing you.
2 Rectangle in proportion and
perspective.
3 Archway with its top curve
placed on the centre line.

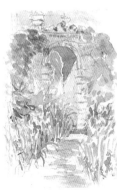

Archway

13 x 7 cm (5 x 3 in)
In this tiny watercolour and
pencil sketch, the archway
only turns away slightly. It
would look wrong if it was
not positioned properly.

Circles in perspective

You may wish to draw the face of a large clock, a circular window, or a circular floor pattern in perspective. Begin by checking the width and height – keep the pencil at right angles to your body, *not* pointing towards the object! Then construct a rectangle, in perspective, around the object and find the centre point. Your circular object will now be elliptical.

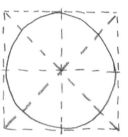

Finding the centre
Put a rectangle around your circle. Find the centre of the rectangle (see page 134). Notice where the circular form changes direction where it touches the extended lines.

Circle 'in perspective'
The top and bottom lines would follow through to the vanishing point at eye level. The circle has become an ellipse, with the central point closer to the 'back' than the front.

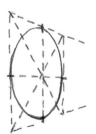

Simple aids for checking angles

Here are two quick ways to check angles in a scene. The 'clockface' method is simple and effective. Draw the angle freehand, as accurately as you can. Line your pencil up with the angle in the scene. In your mind's eye, the pencil represents the hands of a clock; see what 'time' the pencil describes and check this against the angle you have drawn.

Make a simple angle gauge, using two pieces of firm cardboard and either a paper clip or split-pin paper fastener. Open up the gauge and line it up with the angle in the scene – check it against your drawing.

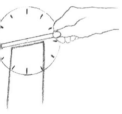

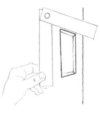

Clockface method
Use your pencil to judge an angle, lining it up with an imaginary clockface in your mind's eye.

Angle gauge
Just line up the gauge with the angle in the scene; nothing could be simpler to use.

ARCHITECTURAL TEXTURES

Man-made surfaces often have interesting textures, which can be explored with different media. I offer a few examples here, but you should spend some time studying textures and finding different ways to describe them. Often, suggestion works just as well as detail; suggesting bricks or roof tiles with just a few shapes may tell the story sufficiently well. After all, when we look at a brick wall, we do not 'see' every brick; our eyes take in a general impression and an impressionistic approach may be perfectly adequate for a sketch.

Bricks

A dip pen was used to draw 'bricks' using watersoluble inks, and before the lines were fully dry, a little water was dropped onto the drawing, softening some of them. A few extra lines were drawn into the wet wash (bottom left) which were soft and out of focus.

Rough painted plaster

Watersoluble coloured pencils were used for the plaster area and the bricks, and various colours of pencil, rubbed onto some sandpaper, were allowed to fall and blend into the wet wash.

Paving

This was sketched with a charcoal pencil, and the charcoal spread with a finger. Then the lines were sharpened up with the pencil and the dark areas of broken stone were added last.

Wooden post

A 3B pencil was used. Some white of the paper shows through to emphasize the texture.

WATER

The wonderful thing about water in the landscape is that it often acts as a mirror, reflecting both the sky and landscape features. When reflecting the sky, it also acts as a force for light in a drawing. Sketching water is mostly about drawing what is happening on the surface. Even shallow water which is transparent enough to show rocks and stones on the bottom will have surface ripples which catch the light or reflect what is around them.

Ripple reflections in watersoluble pencil
Studying ripple patterns can be mesmerizing, but surface ripples often repeat their shapes, making them easy to draw.

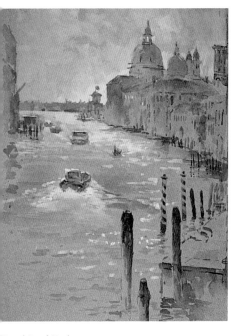

Grand Canal, Venice
27 x 20 cm (11 x 8 in)
Watercolours and a tube of gouache were used for this sketch;
keeping materials to a minimum is sometimes essential.

WHAT SHALL I WORK WITH?

Pencil

This quick sketch was done in a cartidge paper sketchbook
with a 4B pencil. The tonal areas were applied by sharpening
the pencil to a long point and then using the side of the
lead flat against the paper. The light on the water is simply
the white of the paper. Notice how the ripples, suggesting
water movement, are larger and more obvious in the
foreground than further back in the picture, where simple
horizontal lines suggest the water surface.

Ink-and-wash with watercolour

A watersoluble brown pen was used, with slanting strokes for the shadow sides of the rock, and the distant trees. This is a very rough sketch, as you can see from the quality of the marks, but a good sense of light on the water was achieved when the ink marks were melted with a little water. When the brown ink-and-wash image was dry, blue watercolour was added for a little variety.

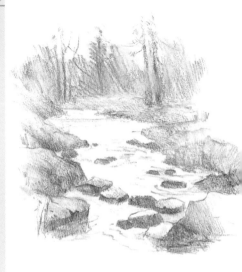

Watersoluble coloured pencils

A variety of different colours was used, one colour lightly put down over another, and when a tiny touch of water was used to soften some of the strokes, the colours fused together in places. Only a little water was used, allowing some of the pencil strokes to remain for a lively, textural effect. More pencil strokes were added when the damp areas were fully dry.

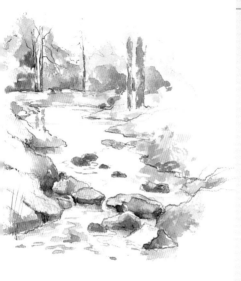

encil and watercolour

encil was used for the outlines of the rocks and trees, and
left to show through the subsequent applications of
atercolour, which were gently 'touched' down onto paper
hich was wetted in places with clean water. Some dry
rush scumbling suggests texture on the rocks, and in the
stant foliage of the trees. The white of the paper suggests
ght on the water.

STILL WATER

Still water acts as a mirror, reflecting either the light from the sky or objects surrounding the water. There may well be the occasional small ripple, caused by a fish or by a breeze disturbing the water, but this is useful to suggest the surface of the water. Whatever medium you use, and whatever techniques you choose for representing still water, the important thing is to observe carefully, and then squinting will help to simplify what you see.

Sparkle on water
With watercolours, the ripples were 'drawn' using the edge of a plain wax candle. A wash of watercolour was floated over the top.

Small ripples
Soft 6B pencil was rubbed with a torchon, and simple horizontal suggestions of water movement were lifted out with a putty eraser.

Reflections in still water

Reflections are never quite the same tone as the objects they reflect. There is a simple rule of thumb to follow: the reflection of a dark object will always be slightly lighter than the object, and the reflection of a light object will always be slightly darker than the object. This applies to the sky, too, so do not put blue water under grey stormy skies.

Often, a reflection seems to be longer than the object it reflects – measure to check this.

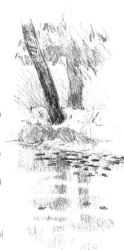

Reflections

This sketch was done with a black conté pencil. Notice how the reflections are slightly lighter than the tree trunks. The dark marks on the water represent floating leaves and debris; the light erased strokes suggest the surface plane of the water and break across the vertical strokes of the reflections.

MOVING WATER

Water flows in rivers, and tumbles and swirls around obstructions. Large areas of open water can be gently or violently disturbed by the wind. Before you begin to sketch moving water, it is best to sit quietly for a while and simply to watch the patterns created in the surface. The tops of ripples or wavelets may reflect the sky, whereas the water between the ripples may reflect surrounding objects. Choppy water tends to reflect less than still water, but there may still be some hints of reflections.

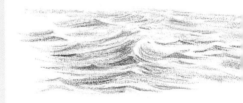

Choppy water
This small study of a patch of choppy water was done with a variety of coloured pencils. There is a suggestion of light on the moving water, and also some colourful reflections from the surroundings.

Surface obstructions

Water swirling gently around a surface obstruction will form interesting patterns.

1 Begin by sketching the main shape of the rock, using a felt pen.

2 Suggest water swirling around the rock with a green brush pen.

3 Switch to a grey brush pen. Use broken strokes to suggest the shadow of the rock down into the water.

WATERFALLS

Sketching the rushing water of a waterfall is a great challenge, which is particularly enjoyable when the water falls into masses of frothy foam at its base. The water will contrast well with the rocks surrounding it. Capturing the speed and movement of the water makes for a fun sketching experience.

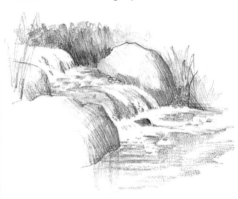

Watersoluble graphite pencil
When the sketch was complete, the pencil marks were softened with a little water, giving a partly-pencil, partly-watercolour effect.

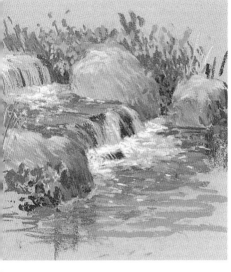

Summer Stream

15 x 20 cm (10 x 8 in)

The same scene, captured in pastels on coloured paper: warm,
light colours were used for the sunlit rocks, with greens for
the foliage. Horizontal marks of ochre and warm green
were used for the shallow water, hinting at the rock forms
beneath. Where the water tumbles over the rocks, soft blues
suggest shadow. White was used for the foam and bubbles.

THE COAST

Almost every area of coastline offers us fantastic sketching opportunities – the sea itself, the texture of the beach and the debris on it, the figures, birds and animals on the beach, the cliffs and rocks surrounding it, the harbours and boats – the list is almost endless.

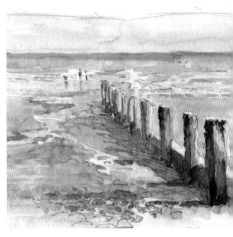

Climping Beach
15 x 25 cm (6 x 10 in)
This was done with pencil and a pocket watercolour set.

The sea is a huge expanse of water, greatly influenced by the mood of the weather, which will affect the behaviour and the colour of the water dramatically. Looking along the shore, as well as out to sea, will give you plenty of interesting sketching material. If you do not live by the sea and a sketching trip is a rare occurrence, take a pocket camera with you to back up your sketches with recorded information.

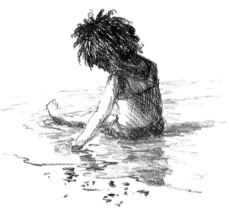

Curly-topped waterbabe

Pastel pencils are good for on-location sketches like this – they are so easy to carry. Be sure to fix your sketches when they are finished to protect them from smudging.

WAVES AND BREAKERS

Watch the action of waves and make quick studies. Study the direction, size and colour of each group of waves. Look for distinct shapes revealed by dark and light areas. There will be shadow beneath the crest of a wave, while the rising curl will often be paler in tone and translucent. Coloured pencils were used for these studies; they are lightweight to carry and quick to use.

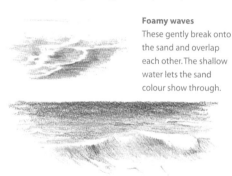

Foamy waves
These gently break onto the sand and overlap each other. The shallow water lets the sand colour show through.

Breaking wave
Light shines through as it rises from the main body of water. The white paper is left to suggest foam. The sea is dark in tone at the horizon; unlike land, which is usually lighter in the distance.

THE BEACH

Areas of beach furthest away from you (sandy or pebbly) have less texture than that under your feet. Suggest a few pebbles, or undulations in the sand. Grey pebbles are subtly colourful, and sand is seldom simply yellow: it may be white-ish, pale gold, yellowy-grey or pink.

Sand and sea

Watersoluble ink pens created the initial washes of pink-gold sand and blue sea. The marks were softened with water, and small touches suggested dips in the drier sand. These marks partly dissolved, giving soft edges. When dry, chalk pastel was used for the white sea foam, and a purple-grey shadow over the dark, wet sand. Gold-coloured pencil, stroked over the top of the sandy area, suggests texture.

Damp sand

Watercolour washes of pink and yellow were flooded on to the paper, and while very wet, watersoluble pencil was shaved into the wet wash.

ROCKS

Rocks can be smoothed by the water or be craggy and jagged. Try to capture the main forms of the rock, as revealed by the light. Simplify but do not generalize rocks into lumpy shapes. Look out for changes of colour and tone after you have established the main form. A dark patch on the light side of a rock can be confusing, so make a note of the direction of the light. Fissures in rocks add interest and character as do surface textures. Rockpools reflect the sky and are great to include, providing light and interest in a sketch.

Shape of the rock
Draw the shape with its changes of plane. Note the direction of the light. Watersoluble coloured pencil is then used: a pale colour for the sunlit faces and darker tones for the shadow.

Variations in colour
Put strokes of dry colour over the rock and shadow area. Soften the marks with a damp brush. Whilst the image is still damp, continue to add darker, stronger marks for the variations in colour in the rock.

CLIFFS

If you look carefully at a wall of cliff, you should be able to discern its structure. See if you can discover which way the strata runs, and suggest this in your drawing. You may only need a few simple lines or marks, to suggest the way that the cliffs are formed. Cliffs will add drama and scale to a scene, and small figures seen against towering cliffs will give a wonderful sense of their grandeur.

Cliff face

A dip pen was used, pressing hard in places for dark fissure lines. The drawing was sprayed with a little clear water to break up the marks and cause jagged runs. Watercolour washes were built up to suggest rock shadows and while wet, more pen lines were added. When dry, cracks and fissures were added.

FIGURES ON THE BEACH

These make perfect sketching subjects, particularly those sitting still or fast asleep! A subject lying down needs to be treated rather like a still life; the shape may be unfamiliar to you and foreshortening will occur if a figure is lying with the feet or head towards you, so do check the proportions carefully.

Figures at play or perhaps at work, for example in a harbour scene, need to be sketched simply and quickly without details. Concentrate on the essential movement or squint to capture the silhouette. Figures can make a painting come to life, so a sketchbook full of figures is a very useful resource.

Watercolour sketches

These were done unobtrusively in a sketchbook with a pocket watercolour set. Aim to capture the main shape and suggest the shadows on the body to reveal the form. You can work directly with a brush, or over a pencil sketch

Working small

Working like this in a pocket sketchbook gives you a chance to capture the different poses of people relaxing on the beach.

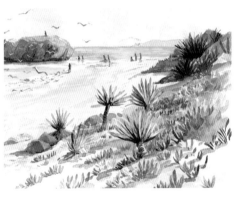

Spanish Beach

13 x 17 cm (5 x 7 in)

I was initially fascinated by these strange, almost alien plants growing on the beach. The sketch developed further when the people and birds arrived to animate the scene.

BOATS

Boats must look convincingly seaworthy and be drawn accurately to look right – a good sketch of a scene can be ruined by a badly-drawn boat.

Check the proportions

Notice how a boat will tilt on dry ground; make sure all the angles follow through. Watch how the water rises and dips along the side of a floating boat. If a boat has a mast, check the height and thickness in relation to its boat. Study different shapes carefully – boats vary dramatically in their shape and size. In fact, if you think of a boat in the same way as you might consider a figure, you can use all the same drawing methods to check its proportions.

Proportions
See how this boat, when seen from a foreshortened angle, 'fits' into a square. This is an excellent starting point.

Lining up the elements

The prow of this boat is much higher than the stern. Note where corners line up and the tilt of the top plane of the boat.

Greek Boat and Reflections

13 x 17 cm (5 x 7 in)

You do not have to include the whole boat – a more unusual viewpoint or section may be even more interesting. Notice the reflection of the water ripples on the side of the boat, and the subtle reflections both into the water and onto the bottom of the harbour.

HARBOUR PARAPHERNALIA

A harbour, particularly at low tide, can be a rich source of sketching material: ropes, chains, bollards, lobster pots, nets, cranes, old propellers and workmen. Harbour walls can be exciting to draw, with their interesting textures and changes of colour and tone. Puddles on the harbour bottom filled with oil and seaweed can be a subject, as can seagulls flying or perching on masts and walls, adding life and interest to the scene.

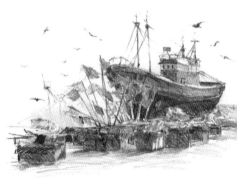

Essaouira Harbour, Morocco
17 x 22 cm (7 x 9 in)
This was sketched on the spot using pastel pencils. The birds were more difficult to capture than the ship and flags!

Lobster Pots Against a Harbour Wall

15 x 20 cm (6 x 8 in)

An initial ink drawing was made in a watercolour sketchbook
with a dip pen and Dr Ph Martin's concentrated watercolour.
Over the drawing, washes of dilute colour were used,
together with sprayed clear water, which dissolves some
of the tightness of the linear work. The washes were built up
gradually until the right depth of tone was achieved. When
the sketch was dry, some of the net lines were scraped out
of the dark tonal areas with a very sharp blade, giving an
impression of light catching the threads here and there.

FIGURES

It is really satisfying to be able to create a successful sketch of a figure. However, you will need to hone your observational skills because although you do not necessarily need a highly detailed knowledge of anatomy to draw a figure, incorrect figure drawing is very obvious. You may be lucky enough to have family or friends who will pose for you for a while. Then you will have time to study their proportions, and to use close observation.

Sketch people in the park, libraries, stations, cafés, even people you see on TV. Draw lightly and do not rub out. When you have filled a sketchbook, look back at the first drawing and see how much you've improved.

Reclining Figure
15 x 10 cm (6 x 4 in)
This quick sketch was done with conté pencil.

Watching TV with the Cat
15 x 15 cm (6 x 6 in)
A blue coloured pencil was used for this child and cat.

If you always carry a sketchbook and practise at every opportunity, dry media will suit your purpose best. A pencil or two is all you need! If you have a model, and a little more time, try some watersoluble media or even direct 'drawing' with a brush and watercolours.

WHAT SHALL I WORK WITH?

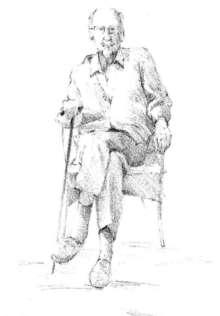

Pencil

This drawing of a seated elderly man was done with a 4B pencil on some cartridge paper.

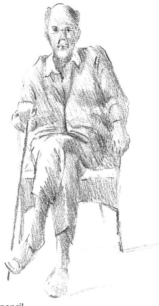

Coloured pencil

Two coloured pencils were used – a blue and an orange. The orange was reserved for the light-struck areas and the blue for the shadows. The blue works well on its own, as in the white of the shirt and the chair, but it is particularly good as shadow tone over the orange, on the clothing.

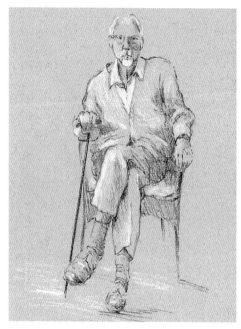

Conté pencils

In this variation, I have used two conté pencils – black and white – on toned paper. The paper colour reads as a third tone. This is a very effective and satisfying way to work.

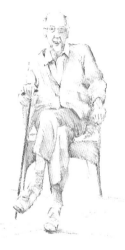

Watersoluble graphite pencil

Here we have a shift into water media. This sketch of the same subject was done with a watersoluble graphite pencil – a 4B – and when the drawing was complete, the shadow areas were then 'softened' with a brush which had been dampened with clean water. Some of the pencil marks show through these 'washes' adding an interesting textured effect which you would not achieve with pure watercolour. You can see this particularly clearly on the floor beneath the figure where the marks are only partially melted.

MEASURING FIGURES

It is not too difficult to 'measure' a standing figure. You can take the size of the head as your unit of measurement and see how many 'heads' there are from top to bottom.

Dot method

But, if the figure is seated, lying down or bending, the shape is more difficult to analyze and measure. Seeing the shape as a whole, and using the 'dot' method (below) measuring height and width first, helps enormously.

Using the dot method
Squint to simplify the overall shape and measure the biggest distances – height and width. Make four dots on your paper: top, bottom and two sides.

Draw freely
Having made the dots, draw freely and check the drawing by measuring smaller shapes.

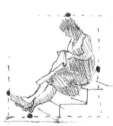

Scan the figure
It also helps to 'scan' the figure, up and down, using your pencil vertically as a plumb line, and horizontally to check across the figure to see where things line up. This 'mental grid' is a wonderful tool, so try to practise using it as often as you can.

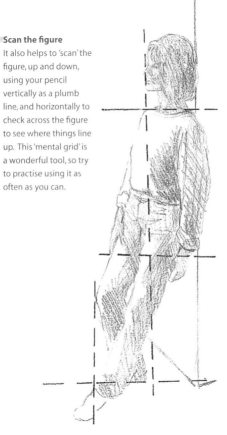

FIGURE DYNAMICS

Bodies can stretch, twist and sag. The pelvis can tilt; shoulders can rise. When the weight is on one leg, the hips will slope and the shoulders will compensate in the opposite direction. Look out for these dynamics: they will give animation to your figures. In your mind, consider the skeleton, and draw in a swift line for the spine, and the angles of shoulders and hips.

Quick results

To capture a figure swiftly, it is best to use an appropriate medium. Charcoal and conté will give very 'fast' results, as areas can be quickly blocked in or smudged to give a sense of form.

Lines and angles

The orange lines (left) follow the lines of the spine and shoulders and, in the standing figure (above), the hips. It is helpful to note that often, when the shoulders angle one way, the hips go in the opposite direction.

When drawing clothes, consider the body beneath the fabric and 'drape' the fabric over the form below, following how it falls or clings to the body.

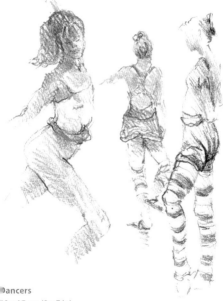

Dancers
20 x 17 cm (8 x 7 in)
This sketch was made in undissolved watersoluble crayon.

FIGURE PERSPECTIVE

When you are sketching figures moving through a scene, there are two very important factors to take into account: figures will appear to reduce in size as they move away in space; and whether you are standing or sitting to sketch will have a huge impact on how you draw the figures.

If you are standing

If all the figures are standing, or walking, their heads (allowing for height variations) will all be at your eye

1 Here we see that the heads of the people above our eye level gradually descend towards the horizon.

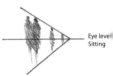

Eye level
Sitting

Eye level
Standing

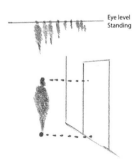

2 If we stand up to draw, most heads will be in line with our own.

3 Scan across the scene to locate the head and feet of the figure.

evel. Their feet, which are on the ground below you, will conform to ground perspective rules, and they will move 'up' towards eye level.

If you are sitting

Your eye level will be lower, and thus the heads of the figures furthest away from you will be lower than those in the foreground, who may tower over you.

ndian Market

3 x 17 cm (5 x 7 in)

stood to sketch this scene in pencil and watercolour, tucked way in a corner with my back to the wall. Notice how all the eads, bar those sitting on the floor, are at almost the same eight even though the scale changes.

FIGURE GROUPS

The best way to sketch a group of figures is to see them as one large shape. Squint to simplify details and draw the main large shape. Add heads and legs and enough details to show that the group is composed of a series of figures. If part of the group is

Group of figures

This group of figures was really nothing more than a coloured 'blob' and yet, surprisingly, it looks like a group of figures because of the suggestions of heads, and the overall shape. Notice how details such as feet really are not needed to tell the story.

closer to you, and you can
easily discern individual
figures, you can draw the
main figure shapes more
carefully, and suggest those
further away by bunching
them together and just
simplifying details. A good tip
is not to make heads too big,
it is better to make heads a
little smaller than you think
they should be. Only children
have heads that are big in
proportion to their bodies.

Watercolour couples

Above and left are small watercolour
'try-outs'. The essential shape of
each pair of figures was sketched in
quickly and, while wet, more colours
added. Notice how observation can
make a difference – wide shoulders
for a man, fuller hair for a woman.

FIGURE 'QUICKIES'

If you carry a sketchbook with you all the time, you will find plenty of opportunity to do some quick sketches – just a few moments to capture even part of a pose is good practice. It is not strictly necessary but, if you find you have the time, do try to include some suggestion of the figure's surroundings – this will not only provide scale but your figures will also look more 'anchored'.

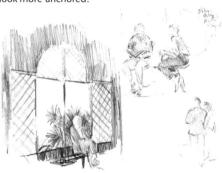

Moroccan Airport
10 x 15 cm (4 x 6 in)
While waiting at an airport, keep a small sketchbook and pencil to hand. This was sketched with a 3B pencil – the surroundings help to anchor the figure in the window.

Be unobtrusive
Sitting behind
someone will give
you the chance to
sketch unnoticed!
This drawing was
done in red conté,

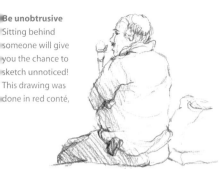

Travelling companions
If you often travel with
someone else who
sketches, they will prove
to be good material for
sketching, too. This was
done with a 4B pencil.

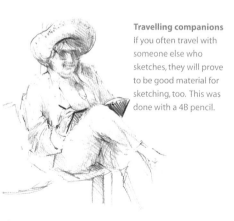

COUNTERCHANGE

You may want to use a figure sketch in a painting at a later stage. Although the eye is always drawn to figures in a painting, nevertheless it is a good idea to look out for the opportunity to use 'counterchange' for added interest and drama. It is a great tool to use.

Counterchange is simply 'light against dark, dark against light'. So, when working with a figure, look out for light figures against a dark background, near to dark figures silhouetted against a light background.

Crouching figures
These were drawn with a 4B pencil and are a good example of counterchange. One is light against dark; the other is dark against light.

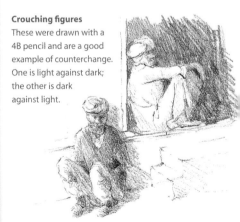

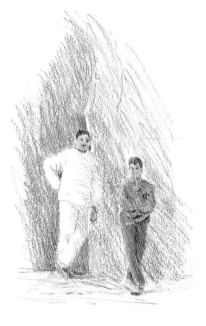

Standing figures

In this sketch made with coloured pencils, the smaller figure is set against the shadow on the wall but is still darker than his surroundings, contrasting with the light figure against the dark ground. This could be used as the focal point in a painting and would attract attention immediately.

PORTRAIT BASICS

To be able to draw a reasonable likeness of a person, it is really important to place the features accurately, and for all the proportions of the face to be measured properly.

Measuring proportions

A good general rule to use is that the face can be divided into three equal parts:

1 Hairline to eyebrows.
2 Brows to nose base.
3 Nose base to chin.

The proportions of the features are nearly identical on every face, regardless of sex. If you begin with standard proportions and placement, you can then make adjustments as required for your model's face.

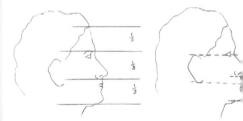

Portrait proportions
As a general rule, a face can be divided into three equal parts.

Lighting

Good lighting, ideally from one source and to one side, will help greatly since the shadows created by the light will define the structure of the features of the face beautifully. Remember that nothing, even reflected light in the side of the face which is in shadow, can be as light as the lit side of the face.

The light will also show where changes of plane take place – for example, where the side 'pane' of the head meets the 'front panel'. Highlights tend to occur at plane breaks, and on the bony ridges.

Girl's head

In this sketch in brown conté pencil, the light strikes the front section of the face, casting shadow to the left. Notice how the basic front and side planes of the head are clearly revealed.

FEATURES

A very basic understanding of anatomy will help you to draw features which are really believable, rather than child-like caricatures or inaccurate 'suggestions' of eyes, noses and lips.

Eyes, noses and mouths

The eye is a ball, sitting inside a cavity – the eye socket. Eyelids wrap around the ball, the upper lid being twice the thickness of the lower lid. The upper lid overlaps the lower lid at the outside corner, which is fractionally higher than the inside corner.

Sketching eyes
Highlights will provide life and vitality to a portrait. A highlight reflects off the fluid in the eye, and the highlight is usually found on the iris – not the pupil – and under the upper lid, at the base of the shadow formed by the lid. The highlight should blend gradually into halftone, which in turn becomes shadow as the form turns away from the light.

Sketching noses

A nose has top, front, bottom and side planes. Each plane is at
a different angle to the light source, and differs in tone value.
The underlying bone and muscle structure is worth learning.

Sketching mouths

The muscles surrounding the outside corners of the mouth
are shaped like doughnuts, and the heavier the features, the
more pronounced this underlying shape will be. The lips, too,
are composed of separate muscles, so look hard to see these
shapes. Correctly drawn lips will show how they are attached
to the surrounding tissue and grow out of the form.

PORTRAIT STUDIES

Male Portrait

10 x 15 cm (4 x 6 in)

Note how the linear marks curve
over the form of this dark blue
ink sketch done with a dip pen.

Arab in Profile

5 x 7 cm (2 x 3 in)

This simple profile in pencil and
watercolour is perhaps more
about the scarf than about the
face, but it was fun to draw.

Man's Head
10 x 10 cm (4 x 4 in)
Red and white conté was
used on a coloured ground.
This was favoured by the
Old Masters.

Lady with Glasses
5 x 5 cm (2 x 2 in)
This was done with a 2B pencil
in a pocket sketchbook while
waiting at the airport.

FURTHER INFORMATION

Here are some organizations and resources that you might find useful.

Art Magazines

The Artist
Caxton House, 63/65 High St,
Tenterden, Kent TN30 6BD
tel: 01580 763673
www.theartistmagazine.co.uk

Artists & Illustrators
The Fitzpatrick Building,
188–194 York Way,
London N7 9QR
tel: 020 7700 8500

International Artist
P.O. Box 4316, Braintree,
Essex CM7 4QZ
tel: 01371 811345
www.artinthemaking.com

Leisure Painter
Caxton House, 63/65 High St,
Tenterden, Kent TN30 6BD
tel: 01580 763315
www.leisurepainter.co.uk

Art Materials

Daler-Rowney Ltd
Bracknell, Berkshire RG12 8ST
tel: 01344 424621
www.daler-rowney.com

Winsor & Newton
Whitefriars Avenue,
Wealdstone, Harrow,
Middlesex HA3 5RH
tel: 020 8427 4343
www.winsornewton.com

Art Societies

Federation of British Artists
Mall Galleries,
17 Carlton House Terrace,
London SW1Y 5BD
tel: 020 7930 6844
www.mallgalleries.org.uk

Society for All Artists (SAA)
P.O. Box 50, Newark,
Nottinghamshire NG23 5GY
tel: 01949 844050
www.saa.co.uk

Bookclubs

Artists' Choice
P. O. Box 3, Huntingdon,
Cambridgeshire PE28 0QX
tel: 01832 710201
www.artists-choice.co.uk

Painting for Pleasure
Brunel House, Newton Abbot,
Devon TQ12 4BR
tel: 0870 4422 1223

Videos

APV Films
6 Alexandra Square,
Chipping Norton,
Oxfordshire OX7 5HL
tel: 01608 641798
www.apvfilms.com

Teaching Art
P. O. Box 50, Newark,
Nottinghamshire NG23 5GY
tel: 01949 844050
www.teachingart.com

Internet Resources

Art Museum Network
www.amn.org

Artcourses
www.artcourses.co.uk

The Arts Guild
www.artsguild.co.uk

British Arts
www.britisharts.co.uk

British Library Net
www.britishlibrary.net/
museums.html

Color Matters
www.colormatters.com

Galleryonthenet
www.galleryonthenet.org.uk

Jackie Simmonds
www.jackiesimmonds.com

The Painter's Keys
www.painterskeys.com

Painters Online
www.painters-online.com

WWW Virtual Library
www.comlab.ox.ac.uk/
archive/other/museums/
galleries.html

WetCanvas!
www.wetcanvas.com

INDEX